THE COST OF CULTURE:

Patterns and Prospects of Private Arts Patronage

Edited by Margaret Jane Wyszomirski
and Pat Clubb

ACA BOOKS
American Council for the Arts
New York, New York

ACA Arts Research Seminar Series Coordinator: Sarah Foote

Edited by Barbara Conover and Bruce Peyton
Jacket design by Joel Weltman, Duffy & Weltman

Director of Publishing: Robert Porter
Assistant Director of Publishing: Amy Jennings

Library of Congress Cataloging in Publication Data:

The Cost of Culture: Patterns and Prospects of Private Arts
Patronage/edited by Margaret Wyszomirski and Pat Clubb.

 p. cm. — (ACA arts research seminar series; 6); Bibliographies.
1. Arts patronage — United States. 2. Arts — United States — Finance.
I. Wyszomirski, Margaret Jane II. Series
NX711.U5C67 1988 700'.79 — dc19 88-27289
ISBN 0-915400-76-6 (pbk)

*The ACA Arts Research Seminar Program
was made possible by a generous grant
from the Mary Duke Biddle Foundation
the Reed Foundation,
the John Ben Snow Foundation, and
the New York Community Trust*

CONTENTS

About the Authors *vi*

Acknowledgments *ix*

Sources of Private Support for the Arts: An Overview *1*
 by Margaret Jane Wyszomirski

The Baby-boom Generation: Lost Patrons, Lost Audience? *9*
 by Judith Huggins Balfe

Understanding Foundation Policy Choices
and Decision-making Procedures *27*
 by Pat Clubb

Corporate Support for Culture and the Arts *45*
 by Michael Useem

Government Leverage of Private Support: Matching Grants
and the Problem with New Money *63*
 by J. Mark Davidson Schuster

About the American Council for the Arts *98*

ABOUT THE AUTHORS

Judith Huggins Balfe is Assistant Professor of Sociology at the College of Staten Island-CUNY. After earning a B.A. in Art History from Wellesley College and working in museum education for a decade, she completed her M.A. and Ph.D. in Sociology, respectively, at the New School for Social Research and Rutgers University. She has written frequently on the social meanings and institutional production of the arts. She is a member of the American Council for the Arts Research Advisory Council

Pat Clubb holds a Ph.D. from the University of Texas, Austin, Department of Political Science. While at the University of Texas, Dr. Clubb taught several courses on introductory American government, public policy, and institutions. Her primary research and teaching interests have been in the area of budgetary politics, especially as related to nonprofit arts institutions. She has published several articles on the role of the private sector, especially foundations, in the budgetary development of nonprofit arts organizations.

Currently, Dr. Clubb is the Director of Grants, Information, and Research for the Texas Commission on the Arts. This position involves the coordination of the grants process, data management and general research. Dr. Clubb has had extensive experience as a private consultant to various arts organizations. This work has been in the areas of fundraising, board development, and long-range planning.

J. Mark Davidson Schuster is Associate Professor Urban Studies and Planning at the Massachusetts Institute of Technology where he currently holds the Cecil and Ida Green Career Development Professorship. His research focuses on the analysis of government policy vis-à-vis culture and environmental design, and he has served as a postdoctoral fellow in the Research Division of the French Ministry of Culture. He is author of *Supporting the Arts: An International Comparative Study*, an analysis of arts funding patterns in eight countries, and coauthor of *Patrons Despite Themselves: Taxpayers and Arts Policy*, a Twentieth Century Fund Report on tax incentives for the arts. He and Milton Cummings are editor of *Who's to Pay for the Arts? The International Search for Models of Arts Support*, a volume in the ACA Arts Research Seminar Series. He is currently working with the British-American Arts Association developing case studies for their research project on the "Arts and the Changing City."

Michael Useem is Professor of Sociology and Director of the Center for Applied Social Science, Boston University. He is the author of articles and books on the social and political activity of corporations, including the in-

troduction to the American Council for the Arts's *Guide to Corporate Giving to the Arts*, 4th Edition, and *The Inner Circle: Large Corporations and the Rise of Business Political Activity in the U.S. and U.K.* He is also the coauthor of a report published by the National Endowment for the Arts, *Audience Studies of the Performing Arts and Museums: A Critical Review.*

Margaret Jane Wyszomirksi is a member of the Senior Faculty of the Government Executive Institute in Washington, D.C. She has been a Visiting Guest Scholar at the Center for Public Policy Education of the Brookings Institute. From 1985 through 1988 she was director of the Graduate Public Policy Program at Georgetown University. She has written extensively on both the American presidency and on cultural policy and the arts. Dr. Wyszomirski is the co-editor and a contributor to *Art, Ideology and Politics* (1985) and the editor and contributing author of *Congress and the Arts: A Precarious Alliance?* (1988)

ACKNOWLEDGMENTS

One of the most uniquely American traits of the arts in America is the means by which they are supported — that is, their reliance upon the private sector for the vast majority of their support. By private sector I mean the individuals who buy tickets, make donations and volunteer their time; I mean businesses, both small and large, which supply underwriting support to the arts as both good corporate citizens and as crafty marketing strategists; and I mean private foundations which award grants to organizations and individuals for projects of merit.

But our society is rapidly changing, and if the arts are to survive, we need to understand and adapt to those changes. Thus, this sixth volume in the ACA Arts Research Seminar Series — based upon a seminar held June 10, 1988 at Duke University — examines the trends that are shaping the arts' future as the baby-boom generation comes of age and we career headlong into a brave new world of corporate takeovers and global competition.

We are again fortunate to have Margaret Jane Wyszomirski as an editor of a volume in this series. This time, she has teamed with Pat Clubb to produce a provocative and timely work. Thank you both for your wisdom, enthusiasm and tireless efforts, without which this monograph would not have become a reality.

I am grateful as well to the authors of the papers, presented at the seminar and contained within these pages, for so generously sharing with us their intelligence and insight: Judith M. Balfe, Pat Clubb, J. Mark Davidson Schuster and Michael Useem. And I would like to extend a special thank you to Bruce Payne, director of The Leadership Program at Duke University, for helping to organize the seminar.

Finally, I would like to thank the funders of this project whose substantial support is testment to the importance of the subject: the Mary Duke Biddle Foundation, the Reed Foundation, the John Ben Snow Foundation, and the New York Community Trust.

SARAH FOOTE
Coordinator
Arts Research Seminars

SOURCES OF PRIVATE SUPPORT FOR THE ARTS: AN OVERVIEW

by Margaret Jane Wyszomirski

The arts in America have always been supported primarily by private patrons. Although public arts patronage — by federal, state and local governments — has grown significantly during the last twenty-five years, private support continues to predominate. Indeed, among all the nonprofit subsectors receiving direct public support (e.g., health, education, social, civic and legal services), the arts are the *least* dependent upon government subsidy.[1]

Private support for the arts comes from a variety of sources: earned income, individual donors, audience members, corporations and foundations. While each source of private support has distinct patterns in the level and focus of its patronage, they are all interrelated, influencing one another and being influenced by circumstances in their shared artistic, social, economic and political environment. Earned income — from admissions, fees, royalties, and ancillary and other activities — also interacts with various forms and sources of patronage. Furthermore, private patronage interacts with public patronage, in part because both rest upon a common foundation of popular endorsement derived from the individual arts patron who is also a taxpaying citizen,[2] and in part because conditions attached to public patronage, such as matching fund requirements, have made that interrelationship formal.

Three of the four contributors to this volume have chosen to focus on specific sources of private arts patronage, while the fourth has examined the interaction of public and private patronage through the device of the matching grant.

While all sources of support for the arts are important, all sources do not equally support all of the arts. Thus, some idea of the relative importance of each would seem to provide a useful context for the discussions that follow. Table 1 presents a comparison of income sources for selected major performing arts organizations during the 1980s. While not fully representative of all arts organizations or activities, this sample nonetheless illustrates the

TABLE 1: Income Sources for Select Arts Organizations						
	Orchestras		Opera		Theatre	
	1981	1985	1981	1986	1981	1985
INCOME SOURCE						
Total Income (in millions)	$288	$435	$125	$235	$69	$109
Total Earned	57%	58%	54%	56%	63%	65%
Total Contributed	43%	42%	46%	44%	37%	35%
Total Private	31%	33%	37%	38%	25%	26%
Individuals	23%	23%	25%	27%	17%	17%
Corporations	7%	9%	6%	6%	4%	5%
Foundations	<1%	<1%	5%	5%	4%	4%
Total Public	12%	9%	9%	6%	12%	9%
Federal	4%	2%	4%	2%	7%	4%
State & Local	8%	7%	5%	4%	5%	5%

Sources: National Endowment for the Arts, Five-Year Planning Document, 1989-1993 (Washington, D.C.: NEA, February, 1987), p. 41; Opera America; and American Symphony Orchestra League.

various proportions of support the arts derive from a variety of patronage sources and how these have changed during the decade of the eighties.

Clearly, earned income is the single most important source of revenue for arts organizations. For orchestras, opera companies and nonprofit theaters, earned income amounts to over half of organizational annual resources. The proportions are similar for dance companies and for presenting organizations, while constituting approximately 33 percent for art museums, 30 to 40 percent for local arts agencies and service organizations and about 20 percent for minority and neighborhood arts organizations.[3] Although different from donated support, such earned income nonetheless comes primarily from individual arts patrons who pay admission fees. Thus, when the proportion of earned income is added to individual contributed income, the importance of individuals to the support of the arts is overwhelming. Indeed, as Table 1 illustrates, the support of individuals, both through purchase fees and through patron donations, is not only the largest revenue source of the arts but has been the one that has consistently maintained, and in many cases increased, its level during the 1980s.

Furthermore, the individual arts patron is *the* crucial element underlying all other sources of arts patronage. Arts fundraising officers seek to develop individual arts consumers into active patrons and supporters. Individual arts patrons also influence other patronage decisions in their roles as corporate or foundation officers, as elected and administrative public officials,

and as members of the general public or of organized political interest groups.

Public support in terms of combined federal, state and local contributions constitutes a significant financial support source for the arts. But clearly its importance and distribution have been changing. Although total public dollars going to support the arts have increased during the 1980s, federal monies awarded to theater have remained constant while those awarded to both orchestras and to opera companies have declined. As a proportion of organizational income for these three arts activities, public support from the federal government has experienced a substantial reduction—virtually halving in each instance, as can be seen in Table 1. Conversely, public support from state and local sources has generally maintained its proportionate share of support to the organizations surveyed in Table 1, because the actual support dollars coming from subnational governments have consistently risen during the 1980s.[4] Thus, public patronage of the arts is assuming less of a federal emphasis and more of a pluralistic and decentralized character.

Finally, corporate and foundation patronage of the arts, while important, each is smaller than the other sources and tends to vary considerably across art forms and activities. Thus, as Table 1 illustrates, foundation patronage, for example, averages 3 percent of the income of orchestra, opera and theater companies, but ranges from less than 1 percent for orchestras to 5 percent for opera. In comparison, corporate arts patronage amounts to approximately twice that of foundations, averaging 5.6 percent in 1981 and 6.6 percent in 1985 while varying from a low of 4 percent for theaters in 1981 to a high of 9 percent for orchestras in 1985.

Judith H. Balfe, a sociologist at the City University of New York, begins this series of essays with a multi-faceted examination of the giving and attendance patterns of the baby-boom generation, in which she presents a number of provocative challenges to conventional wisdom. She asks us to rethink entrenched assumptions about arts participation, particularly its interrelationship with educational level. The baby-boom generation has "had more direct arts socialization than their elders," yet their "actual arts participation rates are lower than the national average for many art forms," including classical concerts and opera. In attempting to explain this apparent anomaly, Balfe points to inconsistent early arts education experiences, to the decline of the liberal arts components in higher education—which weakened the historical relationship between educational level and arts participation—and to the effect of the sheer size of the cohort coupled with

technological developments in the mass media which have legitimized alternative aesthetic interests.

Balfe explores the possible effects of both the baby-boomers' formative experiences and the present socio-economic condition upon their apparent lack of institutional identification and loyalty to arts organizations. As the first television and stereo generation, baby-boomers have grown to maturity with access to the best in the professional arts, with the apparent consequence that they exhibit less support for amateur and/or regional arts activities they may regard as something less than "the best." Similarly, Balfe draws our attention to the fact — and its possible ramifications — that while the arts audience may have increased and broadened in recent decades, many baby-boomers relate to the arts as *consumers* rather than as patrons.

Pat Clubb of the Texas Commission on the Arts examines facets of the decision-making processes of foundations in their role as "financiers of public goods." She argues that efforts to better understand "how and why this donor makes the decisions that it does" are necessary if nonprofit arts organizations are "to maximize their competitive positions in the funding process." Further, she points out that "foundation behavior cannot be understood only as it relates to the arts" but should be viewed in the broader context of its response to the diverse nonprofit community of which the arts are but a part.

Clubb's findings suggest strategies that arts organizations might use in seeking foundation patronage. For example, over half of her sample of foundations considers community word-of-mouth to be the primary means of soliciting applications, a reminder that the majority of foundations operate in a local arena, even though attention is often focused on the few foundations that have highly visible natural programs in support of the arts.[5]

Similarly, another set of findings underlines the role that both foundation trustees and staff play in decision making and, in turn, suggests appropriate grant-seeking strategies. It is clear that "trustees ultimately control foundation policies and subsequent funding decisions." But at the same time, it is also true that a distinct majority of foundations allow staff to reject applications without and before trustee action. Thus, while formal and considerable decisional power resides with foundation trustees, staff members function as influential gatekeepers of the applicant review process. From the applicant's perspective, then, it would seem advisable to establish channels of communication and familiarity with both foundation trustees and staff.

Finally, she identifies principles that not only may assist arts applicants as they compete for foundation funds, but also indicates obstacles that the

arts community as a whole might address in an effort to enhance the relative competitive position of the arts. For example, foundations tend to be organization-oriented rather than issue-oriented in their decisions and to evidence a strong concern for their image as reflected in the grants that they award; their grant programs are somewhat directed at community problem solving, *but* it is the trustees (with some staff influence) who decide what problems to address, *not* the community. It seems likely that the foundation community will continue to follow a highly individualistic and organization-specific decision-making focus. This approach may benefit those organizations and activities fortunate enough to have access to foundation decision makers and to enjoy prestigious reputations. Conversely, foundations are unlikely to attempt to discern and address general field or discipline issues unless these are well-formulated and persuasively articulated by the arts community.

Next, Michael Useem of Boston University surveys patterns in corporate philanthropic support for the arts, focusing particularly on developments of the 1980s. He identifies not only what kinds of corporations give how much to what sorts of arts organizations, but also discusses what factors affect the incidence, scope and targeting of corporate patronage. He sees a generally stable commitment to the arts at the current rate of 11 to 12 percent of total corporate philanthropic funds but notes that the dollar amount is conditional upon the level of corporate income. Thus, while the proportion of corporate philanthropy going to the arts subsector is likely to remain fairly constant, the potential for dollar increases in the total amount of funds available for corporate grants is linked to both the state of the economy and the income capacity of the corporate sector. If corporate income rises, the amount of corporate money available for support of the arts should also rise.

The arts community can do little directly to enhance corporate incomes. Similarly, there seems very little the arts can do to increase the revenues it attracts from corporate philanthropy except, perhaps, to improve its share of the general corporate philanthropic dollar. However, after two decades of success, the arts are likely to find it difficult to further improve their relative position — both because of increased competition for grants from other nonprofit activities (particularly those laboring under more acute government cutbacks or increased service demands in the health, education or social services fields) and because of the weaker philanthropic attitudes of the baby-boom generation as they move into positions of corporate leadership.

Useem also discusses important institutional and decision-making factors that underpin the patterns of corporate patronage. Some of these fac-

tors may lend themselves to more persuasive efforts by arts applicants, while others may not. For example, like foundation support, corporate patronage is focused locally. Indeed, "impact on the local community" and "geographic location" are the predominant criteria for the award of corporate arts support. Therefore, unless they establish second homes or satellite operations in locations near other possible corporate sponsors, arts organizations are essentially limited geographically in the corporate sponsors available to them.

On the other hand, "management capability" is also an important grant-awarding criterion—a fact apparently recognized by many arts organizations and reflected in the increasing professionalization of arts administration. This increased emphasis on managerial capability is perhaps most notable in the establishment and increasing sophistication of development efforts by arts organizations. For example, according to the Arts Endowment's *Five-Year Planning Document, 1989-1993,* between the years of 1981 and 1985, the development expenses of opera companies increased from 3.4 percent to 5.6 percent of annual expenditures, and those of orchestras rose from 3.5 percent to 4.9 percent.[6] Similarly, the profession of arts administrator, complete with credentialed degree training programs, is largely a development of the past fifteen years. Thus, it would appear that arts organizations have recognized the strategic importance that improving their managerial capability holds for attracting more corporate patronage.

Finally, Useem underlines the importance of the opinions of CEOs both toward corporate giving in general and toward specific arts organizations in particular. As with foundations, the reputation of arts applicants not only with the grant makers at a particular corporation but also among the community of corporate philanthropists is crucial to their success in obtaining corporate support. Clearly, the personal element—in terms of communication and contact with grant makers and their staffs—is crucial to attracting institutional patronage from foundations and corporations.

The fourth essay, by J. Mark Davidson Schuster of the Massachusetts Institute of Technology, explores the interaction of public and private patronage through the device of the matching grant. As Schuster notes, the matching grant is an increasingly popular governmental funding mechanism and one that government agencies have used more consistently in the field of public support for cultural activities than for any other area of nonprofit activity supported by the government.

Three types of matching grant mechanisms are discussed: co-financing, challenge grants and reverse matching grants. This study raises two central issues concerning these "partnership" devices. The first issue—and one dis-

cussed extensively by Schuster — is evaluative: do matching grants succeed in increasing support for the arts? Attempts to assess this matter confront the problem of determining what, in fact, constitutes "new money." It would appear that to achieve short-term gains, arts organizations have developed a wide range of entrepreneurial tactics that serve to maximize public money matches while minimizing the demand on private donors to increase their contributions. Schuster finds that matching grants seem to be more successful in moving existing money around among different arts organizations than in actually generating new private support for the arts. Paradoxically, matching grants seem to have been a more effective catalyst for additional public support than for new private patronage. Thus, while it is questionable whether the apparent short-term financial gains of individual arts organizations can be sustained in the long term, it is clear that meeting the matching requirements of various grant mechanisms has increased the demands placed on the managerial talents of many arts organizations.

A second issue raises the provocative and important question of who is setting the direction in such arts support partnerships and to what effect. In co-financing (at least as it is practiced through NEA project matching grants), it might be argued that the arts set the direction, since the initiative for projects comes from the arts applicants and essential award decision-making power rests with expert peer review panels. In contrast, it is sometimes argued that with challenge grants, the government partner, in acting as a catalyst for private support, and in choosing the art organization to be "challenged," sets the direction which private patrons then follow. Conversely, the reverse matching grant would seem to find the private — usually corporate — patron setting the direction that is then followed by the governmental partner. Schuster explores several possible ramifications of these different control patterns are indicated — for example, that the preferences of corporate donors "are not necessarily in accord with articulated public policy" regarding the arts. Moreover, he asks us to consider whether the preferences and interests of the arts, of artists and of arts organizations are congruent with those of their several patronage partners.

All sources and amounts of patronage are important to the arts, and all have seen dramatic changes during the past three decades. Indeed, during the last thirty years such growth in patronage has both fueled and responded to the equally dramatic growth and proliferation of arts organizations and audiences throughout the United States. Now, however, this "arts boom" seems to have plateaued. As the arts enter the last decade of the twentieth century and stand poised on the edge of the twenty-first century, it seems an appropriate occasion to examine past patterns of patronage and explore the prospects for the future.

NOTES

1. In 1984, the arts received approximately 13 percent of its funds from governmental sources. In comparison, the nonprofit health sector received 35 percent, education received 17 percent and social services received 44 percent, while legal and social services each received 50 percent of their funds from governmental sources. See Virginia A. Hodgkinson and Murray S. Weitzman, *Dimension of the Independent Sector: A Statistical Profile,* 2nd Ed. (Washington, D.C.: Independent Sector, 1986), p. 119.

2. For other studies of the role and interrelations of various sources of arts patronage, see J. Mark Davidson Schuster, "The Interrelationships Between Public and Private Funding of the Arts in the United States," *Journal of Arts Management and Law,* Vol. 14, No. 4 (Winter 1985), pp. 77-105; Kenneth Goody, "Arts Funding: Growth and Change Between 1963 and 1983," *Annals of the American Academy of Political and Social Sciences,* No. 471, (January 1984), pp. 144-157; Margaret Jane Wyszomirski, "Philanthropy, the Arts, and Public Policy" in *Journal of Arts Management and Law,* Vol. 16, No. 4 (Winter 1987), pp. 5-29; and Paul DiMaggio, "Nonprofit Organizations in the Production and Distribution of Culture," in *The Nonprofit Sector: A Research Handbook* edited by Walter W. Powell (New Haven: Yale University Press, 1987) pp. 195-220.

3. These earned income figures were presented by Paul DiMaggio in "The Nonprofit Instrument and the Influence of the Marketplace on Policies in the Arts" in W. McNeil Lowry, ed., *The Arts and Public Policy in the United States* (Englewood Cliffs, N.J.: Prentice-Hall, 1984), pp. 63-64.

4. The actual dollar figures for combined state and local support were as follows: Orchestras, from $24 million in 1980-81 to $5.3 million in 1985; and Opera, from $6.3 million in 1981 to $8.7 million in 1986-87.

5. Paul DiMaggio, "Support for the Arts from Independent Foundations" (New Haven, Conn.: PONPO Paper No. 105, January 1986).

6. National Endowment for the Arts, *Five Year Planning Document, 1989-1993* (Washington, D.C.: NEA, 1987), p. 41.

THE BABY-BOOM GENERATION: LOST PATRONS, LOST AUDIENCE?

by Judith Huggins Balfe

The arts boom of the last 15 years has seen enormous expansion in the number of arts organizations, the amount of both public and private funding and the size of the arts audience. As for public support, National Endowment for the Arts (NEA) funds are tenfold larger than they were in 1970, and state and local arts agencies have tripled in size and budget. Private support has increased as well: corporate philanthropy to the arts has risen to more than $500 million, and the increase in foundation support has been comparable. Of course, individual patrons are also as important as ever.

Just as arts organizations vary in type, size and age, however, so they vary in dependence upon unearned income from all of these sources—from about 30 percent for large resident theaters to as much as 70 percent for local and neighborhood arts agencies and organizations. Yet, even at the greatest proportion, the distribution of such unearned funding is determined by individuals, whether as private patrons or as institutional personnel. Such patrons consider the probability that superior art will be produced for—and ultimately appreciated by—widespread audiences. Thus, in order to obtain outside funding, nonprofit arts organizations must first demonstrate box office support earned in the marketplace.[1]

Obviously, marketplace support presently exists. And many fundraisers justifiably assume that now, at a time when the well-educated baby-boomers are entering the prime years for arts patronage, the expanding audience support of recent years will continue. Even if there are those who hope for a leveling off of support, to distinguish quality from quantity among competing artists and organizations,[2] any leveling off of audience growth presumably would maintain current high levels of arts support. Why, then, do some analysts see reasons for alarm? John Robinson's massive 1982 and 1985 surveys of arts participation (taken for the NEA through federal census interviews) show no significant declines across the board. However, the 1987 Lou Harris survey of American arts participation indicates not a leveling off

but a real decline in total arts audiences of 12 percent since 1984.[3] Allowing for differences of survey instruments, as well as of timing, how should these discrepant findings be interpreted?

Others who have analyzed arts support in recent years have differed even more in method and focus and, like Robinson and Harris, have arrived at somewhat varying conclusions. Nonetheless, there is general agreement that the baby-boom cohort is especially underrepresented among most arts audiences, and is largely responsible for any reported declines in arts participation.[4] Baby-boomers were born between 1946 and 1965; their peak birth year was 1957. Totaling 76 million, they now make up nearly half of all adult Americans. Almost two-thirds of them are over 30; they are no longer a "young" generation. The dimensions of their public and private lives have been both well established and thoroughly analyzed, with conclusions that suggest grounds for some alarm. Generally, as Richard Easterlin argues, a large birth cohort experiences greater social, economic and psychological stress, and hence a lower sense of personal welfare. This, in turn, results in a lower level of identification with the cultural values and institutions of the older generations, and thus in reduced philanthropy and volunteerism.[5]

Of course, there is enormous diversity within any large generation such as the baby-boomers, and a resultant variance in its attitudes toward the different arts. Nevertheless, the cumulative impact of baby-boomer tastes and habits is enormous, especially when these differ widely from those of earlier generations whose tastes and values have been institutionalized in established arts organizations. Here baby-boomers shall be considered as patrons (philanthropists and volunteers to particular arts organizations), as audience members ("box office" attenders at arts events), as consumers (through the mass media without regard to specific institutions or events) and finally as arts administrators. How are baby-boomers different from their elders, and what are the consequences of these differences for the arts?

CHANGES IN SOCIAL CONTEXT: TIME AND MONEY

Baby-boomers grew up during the very years in which their elders were fueling the "arts boom" of the 1970s, making the arts more democratically accessible and socially valued. Accordingly, one might have expected them to participate in the arts more frequently as adults; Robinson reports, for example, that older baby-boomers, at least, had more direct arts socialization than their elders (childhood music lessons, trips to museums and theaters and so forth) Even so, their actual participation rates are lower than the national average for many art forms: 10 percent compared to 13

percent for classical concerts and 4 percent compared to 8 percent for opera, for example – even as they attend museums at two percentage points above the national average of 22 percent per year.[6] What is the meaning of such differences?

Recent changes in social, political and economic institutions have altered – and been altered by – the wider context in which arts participation and patronage occurs. These changes affect everyone, but especially the baby-boomers. For example:

— Inflation has led to a real decline in living standards for many (the "shrinking middle class"), particularly the young.[7]

— Changes in tax laws have resulted in lower deductions for philanthropy, including arts patronage.[8]

— Government cutbacks in social services have increased pressure on private donors (individuals, foundations and corporations) to support charity for the "truly needy" rather than philanthropy for activities such as the arts.[9]

— Corporate takeovers have decreased the number of corporate patron units and otherwise undercut the local or regional loyalties manifest in previous corporate arts support (if only because key personnel move).[10]

— Cutbacks in K-12 arts education during the 1960s, after the first wave of baby-boomers began to flood the schools, have apparently led to a decline in aesthetic understanding among many of this cohort as adults.[11] However, enough of them obtained arts education at the professional level that the supply of superior artists and arts organizations is higher than ever – even if touring international artists competing for American audiences are not counted. Simultaneously, greater sophistication in mass media arts programming and technology has led many other baby-boomers (and their elders) to a declining acceptance of anything less than the best. Accordingly, there is an increased demand for superstars, and a devaluation of local and amateur arts activities. The new opportunity to enjoy the arts without leaving home, through stereo broadcasts and VCRs, has further decreased the incentives to patronize local or regional arts organizations.[12]

— With two incomes necessary to maintain middle-class standards of living – that is, with an increase in the number of women working outside the home – many baby-boomers find that they have less time for "active" leisure. If this change is added to that of wider options for "passive" leisure, some are less inclined to attend arts events (and thus compound the problems for local/amateur artists). They have less time for other kinds of volunteer arts participation as well.[13]

In sum, there are indeed more potential arts participants, if we add the Yuppies to their comparatively more affluent elders, the "Suppies" and "Gumpies" (Senior Urban Professionals and Grown-Up Mature People).[14] But there are also more artists and arts organizations requiring their participation, competing for the declining resources of time and money.

Not surprisingly, then, arts management itself has become more professionalized. This organizational demand has been met by the supply of baby-boomers with graduate degrees from new arts management programs.[15] The growing professionalism in arts administration both compensates for *and accelerates* the recently reported declines in some amateur arts activities and the lowered status and availability of volunteers within arts organizations.[16]

BABY-BOOMERS AS ARTS PATRONS

Whatever their differences in methodology and interpretation, all studies of arts participation and other philanthropic activities recognize the fact that baby-boomers are more highly educated than older cohorts — and higher education is the best predictor of arts participation. By 1980, when the baby-boom "peak year" members were 23, a quarter of the full cohort had *already* obtained at least a bachelor's degree, and another fifth had spent two years in college — twice the proportion of their mothers and half-again that of their fathers in regard to their attaining comparable education by *middle age*. Even though television and rock music were constants in the lives of baby-boomers, so too was an emphasis on getting a college education — out of sheer competition.

But, whatever may be said about their regular schooling (in which, as noted, arts education was often inadequate), the general "content" of their higher education was not the same as it had been, thus weakening the historically recognized relation between educational level and arts participation. Specifically, between 1970 and 1980, Liberal Arts degrees declined in actual numbers as well as in terms of their proportion among the college degrees earned by this much enlarged cohort. The numerical difference was made up by Business majors alone, with Engineering, Computing and other technical degrees adding further to the proportionate shrinkage of the Liberal Arts.[17]

Compared to older cohorts, then, baby-boomers on average have more years of higher education. They were thus *able* to take art and music appreciation courses, another key predictor of arts participation — at least among older generations. However, for baby-boomers, higher education in

general and such arts socialization opportunities in particular have not increased their arts participation to the degree that similar experiences did for their elders. As the Liberal Arts components in a typical curriculum have declined proportionately, courses in art appreciation and practice have become more isolated, diminishing any full understanding of the socio-historical contexts and interrelations of past and present art forms. Simultaneously, the welcome broadening of arts offerings to include both contemporary and non-Western works has undermined general agreement on a canon of classical works to be mastered by all students to serve as the basis for future arts appreciation. One might argue that older arts patrons have simply had more years in which to enrich their experience of the arts; accordingly, baby-boomers will "naturally" attain comparable understanding and increase their participation in time. However, this prediction seems unwarranted if current trends hold. Longitudinal data that allow us to contrast arts participation of different cohorts over time are indeed scanty. But when they are available they seem to indicate that, for most art forms, baby-boomers participate less than did earlier cohorts at the same age.[18]

The arts are not the only field that is suffering such losses: generally, baby-boomers give less volunteer time and less money to all charities than do their elders, even when income, education, occupation and religious behavior are held constant. The declines in volunteer activity in this cohort are particularly striking and cannot be attributed solely to the reports of insufficient time.[19]

When we focus specifically upon arts patrons — that is, donors or volunteers — these losses among the baby-boomers are all the more troublesome. More than nonprofit institutions in the fields of religion, health and education, the arts receive their broadest support from college graduates who are involved professionally in "people-oriented" occupations, especially teaching.[20] Certainly there are large numbers in these occupations, but their typical incomes do not permit much individual philanthropy. And for most younger professionals in these fields, at the point in their careers when their incomes should be increasing at a steady rate, salaries have not even kept pace with inflation; the median income of 25- to 34-year-old male full-time workers declined over 18 percent in constant dollars between 1973 and 1984.[21]

Of course, arts patronage has long depended upon a *very* small number of large donors: in 1985, only 4 percent of the total adult population donated *any* money to the arts, and only 6 percent of *this* small figure gave over $500. (There were enough donors of huge sums that the average arts donation was $210, ranking second behind education — at $290 — among

nonreligious charitable gifts.) The continuing loyalty of such idiosyncratic and wealthy arts donors should not be assumed: presumably they are much like other so-called "heavy donors" (those who gave over $500 *total* to charity in 1985), whose philanthropic priorities shift from time to time. Generally, less than half of such heavy donors gave *annually* to the arts, and less than 0.5 percent ranked the arts at the top of their charitable list.[22] Looking ahead, the loss of a "precious few" *old* arts patrons is unlikely to be be offset by the recruitment of a "precious few" baby-boomers, or by the recruitment of a less devoted larger number — if arts organizations do not make new and accelerated efforts to understand their young would-be patrons.

Historically, elites have patronized High Art in order to establish strong boundaries between themselves and the masses, the supporters of Popular Culture.[23] In contemporary American society, it is likely that such needs are felt more acutely as they become more difficult to achieve. This trend has contributed to both the status and the structural divisions between non-profit and commercial arts organizations, with the former supposedly concentrating upon art for art's sake and the latter "merely" upon entertainment for the mass audience. The need for such status assertion and boundary maintenance surely exists among baby-boomers to an even greater degree than among earlier cohorts: the competitive Yuppies need to try to distinguish themselves from their more numerous peers upon *some* grounds, and acquiring expertise in High Art can serve as well as acquiring expertise in High Tech. Accordingly, some baby-boomers become patrons of arts organizations to provide evidence of being knowledgeable. Others become the recruits for the new arts management degree programs, to become more professional than the "old pros" who are still the senior officers in most arts organizations. Competing against these seniors as well as among themselves, whether as professionals or as volunteer patrons, some Yuppies are likely actually to scorn "amateurish" arts activity altogether. There is some evidence that such individuals are already heavily represented in particular segments of arts audiences, for example, in ballet. They provide much of the support for early music on original instruments, as well as for the increasingly available and enormously sophisticated arts of non-Western traditions.

But all baby-boomers are not Yuppies. In fact, the majority have been called the "New Collars" — those without advanced degrees, working in a variety of technical and service occupations, with even less leisure and income than the Yuppies.[24] They support commercial art forms and the mass media, both of which must constantly produce innovative and trendy offerings simply to attract their attention. Some such programming includes

High Culture Superstars, such as Pavarotti and Baryshnikov. But the "New Collars" have neither volunteered nor been recruited to become arts patrons, having lower professional skills and little discretionary income to donate.[25] They may perform as amateurs in rock groups, but like the Yuppies their aesthetic standards have been determined by high-tech production that only professionals can provide.

Certainly such professionals are in ample supply and outnumber available full-time positions in most arts fields. But unemployed arts professionals cannot readily accept less than standard pay if they are to maintain their standing; they cannot give their work away until they retire. Accordingly, professional arts organizations remain highly dependent upon amateur volunteers, who make up the majority of individual donors as well – and not merely as well-heeled members of the board.[26] However, although some baby-boomers support the arts, they volunteer neither time nor money in amounts comparable to their elders – no more than they do in any other area of philanthropy. The decline of private *individual* patronage makes the arts all the more dependent upon the box office – not just for dollars but also for provision of the quantifiable evidence of audience support necessary to obtain outside *institutional* funding from foundations, corporations and government. Paradoxically, as demonstrated by recent NEH cutbacks in grants to the New York Public Library, the more stabilized arts organizations become, both administratively and financially, the less "needy" they are likely to appear, justifying a reduction in public funding.[27] As time goes on, outside funding agencies are becoming staffed by nonartistically inclined baby-boomers in a context in which the arts are seen as less imperiled than other social institutions. This suggests that appeals by arts organizations may increasingly meet the same lack of interest by agencies which they are encountering now among many private individuals.

BABY-BOOMERS AS ARTS AUDIENCE

In contrast to the general findings concerning philanthropy and volunteering, when the patterns of baby-boom audience participation are examined, intriguing inconsistencies are found. Compared to their elders, baby-boomers attend art museums and jazz concerts more often, and listen more often to classical radio (as programming has expanded and become more eclectic through National Public Radio). However, they participate less in symphony, opera, musicals and serious theater; even modern dance does not attract them as much as it did the next older cohort at the same age.[28] None of these findings should be surprising: with a base of rock music and its analogous forms of theater, dance and multi-media expres-

sion, baby-boomers can still "do their own thing" and attend Springsteen and Grateful Dead concerts or follow New Age artists without regard to "older adult" High Culture.[29] But they had no comparably institutionalized visual arts of equal power and/or sophistication. Furthermore, for young adults with little leisure time and disposable income (and often with a small child or two), museums are like shopping malls in ease, cost and timing of access. Seldom must such visits be planned and paid for in advance.

Jazz too occurs largely in contexts permitting casual and spontaneous attendance, fitting with the other demands in the lives of baby-boomers. Their increased interest in jazz can be understood in terms of another of the differences among members of this huge cohort, one only indirectly related to education and occupation. That is a matter of geography: in those places where there are enough sophisticated young adults to make up a critical mass (for example, Boston, Manhattan and Brooklyn, Washington, Chicago, Atlanta, San Francisco, San Diego and many "university towns" such as Ann Arbor), then jazz, New Age and Next Wave artists and their supporting institutions can thrive without eroding support for "traditional" High Art cultural organizations.[30] The resultant eclectic mix of artists, art forms and audiences is sometimes labeled "postmodern." But outside the largest metropolitan centers, where the numbers and variety of arts institutions are fewer, can such postmodern, crossover art forms be programmed for baby-boomers without offending and thus losing the older, traditionalist patrons and audience?

So far the focus has been upon patronage and audience participation in particular arts organizations, whereby some sense of institutional loyalty might be cultivated and rewarded. But more than was the case for their elders, much that passes for arts education for baby-boomers has been filtered through the mass media. Certainly this route has broadened the arts audience, but it has transformed many within it into a mass of arts *consumers* whose aesthetic experience involves little participatory effort or expectation, and thus little reward from or for individual arts organizations. In the words of one critic:

> To watch the contemporary consumer of art is to observe a victim of *hype*nosis [Contemporary] culture places so many modalities at the consumer's disposal that none of them can have decisive values [So] Yuppies march to art, as General Foy said of the Napoleonic troops of Waterloo, "without fear, without hope."[31]

It is commonly recognized that the often welcomed democratization and popularity of the arts have been accompanied by an aestheticizing of everyday life, which now is understood to permit endless choices of life *styles*.

The need to demonstrate such choices by the conspicuous consumption of material goods has contributed to the swelling of corporate coffers that, in turn, have been tapped to help fund the arts.[32] The social significance of style in nonarts fields has surely led many baby-boomers to greater awareness of the arts at large; in John Robinson's terms, the result is "the more, the more" — that is, the more one participates in one art form, the more likely one is to participate in others.[33] But given the time constraints that affect most of the baby-boom cohort, any increased aesthetic appreciation in one area is likely to mean considerable shallowness in the others with which one is supposed to "keep up." As in other areas of contemporary life, quantifiable factors (time and money) become the primary determinants of judgment.

These issues are particularly important for performing arts organizations; they are less so for museums. One may join a museum or not and, either way, attend as time and circumstance permit; in any case, the artworks remain regardless of audience attention. And, while television has done some superior programming to help to develop appreciation of the visual arts, the originals are so vastly superior to media reproduction that consumerism is a lesser threat to real appreciation. With the performing arts, on the other hand, the mass media often provide superior sound quality and sight lines to live performances; they certainly provide wider access and greater convenience of timing. Although those who "consume" the performing arts through radio and television are far more likely to attend live performances than those who do not, the media still compete for their time and attention — and often win. Yet a live performance must still go on at a unique time and place, however inconvenient for those on tight budgets and schedules. And such a performance must somehow pay its way at the box office during the run of that scheduled production or by the end of the season if the artists are not to disperse, or even leave the field, forever.

For performing arts organizations competing against media consumption, the further variable of tickets must be added, with the choice of single admissions or subscriptions. Studies of various performing arts audiences show that subscribers are wealthier than nonsubscribers — hardly a surprise. But they are also older, and as a group prefer more traditional programming. Institutions that emphasize subscriptions are thus likely to ignore, however unintentionally, the possibly more experimental or "rock-based" tastes of some baby-boomers. Alternately, because baby-boom audiences may need to be "walked through" more of the classic "war horses" than the traditional subscription audience may want to hear, these are not programmed either. Both "mistakes" in programming will surely make it more difficult to attract the maturing boomers, as they become settled enough for

subscription status. In any case, subscription tickets usually are sold at a discount from single tickets; thus the latter are, in effect, subsidizing the former.[34]

In contrast are both commercial and city- and state-supported arts centers that must satisfy a diverse market and/or electorate with an ethnically eclectic mix including jazz, rock and multimedia performances. Here are programmed single concerts featuring individual artists rather than the "house" company. In such cases, younger, less affluent, occasional attenders are not disadvantaged in their choice of performance dates, ticket prices or seating. No wonder baby-boomers attend such performances more often, and established symphony and other companies less often: like jazz clubs, arts centers allow greater individual choice of program, greater equality of ticketing and usually a more casual atmosphere. No previously demonstrated institutional loyalty is expected or rewarded; but, of course, neither is it developed.

BABY-BOOMERS AS ARTS ADMINISTRATORS

All of these issues present dilemmas as well as opportunities for arts administrators. Projections are always difficult, but there is already some evidence for three trends:

First, given the sheer numbers and seemingly short attention span of the potential audience, *any* innovation is likely to be supported (at least for a while), as demonstrated in the short-lived faddishness of the contemporary visual arts scene and the abbreviated "shelf-life" of many who create for the performing arts. However, in such a crowded field, it becomes all the more difficult to justify the continued support that young artists need to mature, in turn making it more difficult for administrators to think beyond the current season.

Second, young artists and arts administrators may find fewer positions in university arts centers, now that their fellow baby-boomers have graduated from college and some declining university enrollment can be anticipated, and their tenured predecessors have not moved on. Instead they are more likely to find work by supplying the enormous consumption demands of the mass media, blurring further any line between High and Popular Culture, between the traditionally elitist avant-garde and the democratic New Age, and between nonprofit and commercial arts organizations. (High Culture has depended upon maintaining these distinctions, at least in the past.) Both of these trends will lead to more competition for administrative talent and, in turn, less institutional longevity on the part of careerist arts ad-

ministrators. How then can they build and sustain such loyalty on the part of patrons and audiences? Without that loyalty, there will be more volatility in arts support, whatever its individual or institutional source.

Third (and to some degree the positive side of the difficulties just noted), baby-boom arts managers obviously have much in common with their managerial peers in corporations, foundations and government agencies, including MBAs from the same universities. They may thus manage to find sympathetic ears for their appeals after all, as the "arts biz" comes to be understood by all concerned to be similar to "biz biz." (Again, that understanding can support both sides of the dispute about taxing the merchandising activities of nonprofit organizations, such as sales desks at museums.) Otherwise, innovative artistic expression may find support as if it were "R&D" (support that has often been denied to "emerging arts") *if* sufficient administrative attention is paid to the bottom line. But the need for financial accountability and long-term box office success may lead to more conservative and traditional programming, especially for institutions dependent upon subscriptions. Combining both forms of programming contributes to a postmodern eclecticism of stylistic offerings, through which risks of *institutional* failure are, it is hoped, diminished. (As all "R&D" funds should be put in the same basket, there will be only minimal funding for each effort regardless of artistic merit, with implications for young artists which cannot be explored here.) The dilemmas remain: how can aesthetic sophistication and institutional loyalty be nurtured among young adults who presently have neither?

Certainly status competition among Yuppies has encouraged some of them to support arts institutions as patrons or season-ticket holders and will continue to do so. The need to be conspicuous in such consumption has already fostered a demand for more openings, galas and benefit performances—a demand well understood and readily accepted by baby-boomer administrators, both within and outside the arts. Thus corporate sponsors obtain "perks" of opening night parties for staff or clients, for example. These broaden the base of arts support beyond the idiosyncratic and wealthy few upon whom the arts have long depended. But they also encourage a glitz and a need for "show biz" surrounding the staging of "media events" and blockbusters which are not always beneficial to the creation and sustenance of the serious arts.[35] If arts institutions have been supported in the past in part to create and sustain an elite of artists and discerning patrons, isn't the loyalty of this elite threatened as the organizations appeal to much broader audiences to meet their ever-increasing budgets? More popularity for the arts means longer seasons, bigger houses, higher salaries for company members and other staff and enormous fees for superstars.[36] The in-

evitable institutional dependence upon the somewhat reluctant baby-boomers — for artists, audiences, patrons and managerial personnel — can only increase these tendencies.

CONCLUSION: WHAT IS TO BE DONE?

Along with the widely recognized defects in the bureaucratic and accounting requirements of the state, corporate and foundation institutions that are appealed to for support, there are some unrecognized virtues. The resultant increase in professionalized arts managers has depended particularly upon members of the baby-boom who talk business in terms their non-arts-oriented peers can understand. As their careers develop, they are likely to move from one arts organization to another, and back and forth between nonprofit and commercial sectors (on occasion serving in state, corporate and foundation agencies that fund the arts). In turn, they are developing networks across and within the institutional boundaries that previously divided the arts from each other and from other sectors of society.

Consider the opportunities these present both for arts philanthropy and for arts education. In general, people are more likely to make donations if asked to do so by someone they know. Where do baby-boomers have time to meet each other and make such requests? At work — and it is at work that people report being most likely to give, if asked.[37] The more comfortable arts managers become in business settings, and the more individual arts organizations find innovative ways to present their offerings in the workplace to educate and enchant both Yuppies and New Collars, the more likely the baby-boomers will be to join their audiences and provide patronage support as well.[38]

Such support could be facilitated by computerized payroll deductions: where the United Way has pioneered, surely united arts funds may follow. Thus, it is possible that arts consortia might extend their interlinkages beyond joint scheduling and sponsorship of particular works and events, and even beyond joint fundraising. Such consortia could develop common memberships as well. If baby-boomers show little institutional loyalty and are unlikely to become subscribers to any single organization for very long, they may find a united arts membership more appealing. Granted: for the organizations involved, there will be difficulties in allocating the funds so as to be fair to both better- and lesser-established groups. But we are accustomed to arts memberships that carry discounts at other institutions (including such nonarts organizations as restaurants). Surely it is not beyond the creativity of the new generation of arts managers to use their linked com-

puters to expand such cooperative mechanisms, and thereby help their individual organization to survive.

They may also find ways to coordinate long-term programming and structured educational efforts, building upon the models of short-term arts festivals that attract people of all ages, tastes and levels of aesthetic sophistication. Obviously, responding to the differences among potential audience segments is as important as recognizing what they have in common.

If the baby-boomers have taught us anything with their high technology, it is that we become more and more similar and connected at the same time that we become more and more individualized. Those who use the arts to perform the latter function may help them to survive by understanding the former, with all its technological and bureaucratic implications. These may provide a crucial stability in an otherwise highly unsettled time. One recent sociological analysis contrasting "settled" and "unsettled" cultural periods has concluded that:

> . . . in unsettled cultural periods, explicit ideologies directly govern action, but structural opportunities for action determine which among competing ideologies survive in the long run [Therefore] in unsettled lives, values are unlikely to be good predictors of action, or indeed of future values.[39]

Given the complexity and diversity of contemporary American culture, and its tremendous underlying economic and political stresses, one can easily argue that our lives are "unsettled." However much the various surveys of arts participation find that Americans support an "ideology" valuing the arts, such values do not consistently translate into active participation, particularly by baby-boomers. On the other hand, those who do not presently value the arts may yet be brought to participation (perhaps through their children), if opportunities are provided for them. Thus, if there is reason for alarm in the present pattern of baby-boom arts support, there also is reason to be encouraged by the fact of its unsettled state. It provides an "open field" of opportunity for those arts missionaries with enough vision, managerial skills and luck to secure the ideological allegiance as well as the behavioral involvement of the presently uncommitted baby-boomers.

NOTES

1. Paul DiMaggio, "Can Culture Survive the Marketplace?" *Nonprofit Enterprise in the Arts*, Paul DiMaggio, ed. (New Haven, Conn.: Yale University Press, 1986), pp. 65-92.

2. Samuel Lipman, in *Arts Education Beyond the Classroom*, Judith H. Balfe and Joni Cherbo Heine, eds. (New York: ACA Books, 1988), pp. 7-10.

3. Louis Harris, *Americans and the Arts V* (New York: National Research Center of the Arts, 1988), p. 4; John Robinson, *Public Participation in the Arts* (College Park: University of Maryland, 1982); "The Demographics of American Participation in the Arts" (College Park: University of Maryland, 1986). Harris has consistently found higher levels of arts participation in previous surveys than have other researchers; one might argue that his finding of a new decline simply brings his figures into closer agreement with those of Robinson and others.

4. Judith Blau, *The Shape of Culture* (New York: Cambridge University Press, 1989); Richard A. Easterlin, *Birth and Fortune*, 2d ed. (Chicago: University of Chicago Press, 1987); Charles Gallup, *Americans Volunteer 1985* (Princeton, N.J.: Gallup Organization, 1986); Louis Harris, 1988; Virginia Hodgkinson and Murray Weitzman for Yankelovitch, Skelly, & White: *The Charitable Behavior of Americans* (Washington: Independent Sector, 1986), John Robinson, 1982, 1986.

5. Easterlin, 1987. See also Landon Y. Jones, *Great Expectations* (New York: Random House, 1980); and Wanda Urbanska, *The Singular Generation: Young Americans in the 1980's* (Garden City, N.Y.: Doubleday, 1986).

6. Robinson, 1986; personal communication, 19 March, 1987.

7. Easterlin, 1987; Stephen J. Rose, *The American Profile Poster* (New York: Pantheon Books, 1986); Urbanska, 1986.

8. Harris, 1988, p. 18, reports an increase in such donations in 1986, but this may be the result of anticipated changes in the tax laws for 1987. In contrast, see Hodgkinson and Weitzman, note 19 below.

9. "Many Orchestras in Financial Straits," *New York Times*, 19 January 1987, C11; "Corporate Pressures Slowing Gifts to Charity," *New York Times*, 8 July 1987, p. A1.

10. This will have an effect upon individual artists as well as arts institutions: Rosanne Martorella reports that outside the major metropolitan centers, up to 50 percent of all art sales have been to local corporate collections (*Beauty in the Boardroom*, Greenwood Press, forthcoming). As for arts organizations, the Dayton Art Institute had only one day in which to raise $2 million to acquire an entire corporate collection, suddenly put on the market when the corporation itself was merged, as reported in "A Bold Stroke," *Horizon Magazine*, June 1988, p. 19.

11. Lipman, 1988; Michael Kimmelman, "The Tempo Is Changing for Music Magazines," *New York Times* 20 December 1987, p. 75.

12. Harris, 1988, p. 36; Robinson, 1986, p. 13.

13. Harris, 1988, p. 26, reports declines of only 3 percentage points in amateur arts activity in total in contrast to 12 percent declines in arts attendance since 1984. Still, even this loss indicates a reversal of the finding from Gallup's earlier survey that volunteers in the arts and culture had increased from 6 percent to 8 percent of all adults between 1981 and 1985—despite the fact that volunteer activity in general declined 9 percent among young adults, and 12 percent among those with household incomes of $20,000-39,999. Presumably those declining trends hit the arts by 1987. (Independent Sector: *Americans Volunteer 1985: a Summary Report*, p. 11; Gallup, 1986, p. 13). Gallup reports that 67 percent of those who decline to volunteer when asked say that they do not have enough time to do so (p. 45). See also "Why All Those People Never Have Enough Time," *New York Times*, 2 January 1988, p. A1.

14. "The Merchandising Gold Mine of Suppies and Gumpies," *Washington Post National Weekly Edition*, 9 May 1988, p. 21.

15. Paul DiMaggio, *Managers of the Arts* (Cabin John, Maryland: Seven Locks Press, 1987); Stephen Langley and James Abruzzo, *Jobs in Arts and Media Management* (New York: ACA Books, 1989), both available through ACA Books..

16. Harris, 1988, and Gallup, 1986, note 13 above.

17. Andrew Hacker, *U/S: a Statistical Portrait of the American People* (New York: Viking Books, 1983), p. 243; *New York Times*, 9 November 1986, p. 34. Michael Useem reports freshman interest in a Liberal Arts major at 40 percent in 1970, at 21 percent in 1980, and at 25 percent in 1988, *New York Times*, 17 May 1988, p. D17.

18. Blau, 1986; John Robinson and Nicholas Zill, "Socialization Experience Differences in Music Participation and Music Preferences," paper presented at the Annual Meeting of the Eastern Sociological Society, Boston, Mass.: 1 May 1987.

19. Gallup, 1986; Easterlin, 1987. Hodgkinson and Weitzman for Yankelovitch, 1986, p. 37, report that for all charities, baby-boomers gave only 1.7 percent of pretax income compared to 2.4 percent for all adults; only 6 percent of baby-boomers gave over 2 percent of pretax income to nonreligious charities compared to 11 percent of those 50-64 years of age. The differences were not just due to age and life cycle: between 1973 and 1983, there was a 29 percent decline in charitable contributions from those 25-34.

20. Robinson, 1982; 1986, p. 9. Margaret J. Wyszomirski has pointed out that arts audiences and patrons, respectively, are comparable in numbers and background factors to those who participate in politics by voting or by running for office: thus the arts are no less "elitist" than politics. However, without PACS and general tax levies for support, the arts are all the more dependent upon idiosyncratic individual supporters. "Philanthropy, the Arts, and Public Policy," *Journal of Arts Management and Law* 16 (Winter 1987): 4.

21. Urbanska, 1986, p. 3.

22. All of these figures come from Hodgkinson and Weitzman for Yankelovich, 1986, p. 20.

23. Herbert Gans, "American Popular Culture and High Culture in a Changing Class Structure," *Art, Ideology, & Politics*, Judith H. Balfe and Margaret Wyszomirski, eds. (New York: Praeger, 1985), pp. 40-58; Paul DiMaggio, "Cultural Entrepreneurship in 19th Century Boston," *Media, Culture, & Society* 4 (1982): 33-50, 303-33, and "Classification in Art," *American Sociological Review* 52, no. 4 (1987): 440-55.

24. "The New Collar Class," *U.S. News and World Report*, 16 September 1985, pp. 59-65; "Yuppie is Dead, Long Live the 'New Collar' Voter," *New York Times*, 19 July 1985, p. B35.

25. Gallup, 1986, p. 20, reports that only 46 percent of high school graduates do any volunteer work, and only 2 percent of them in the area of arts and culture. In contrast, the figures for college graduates are 65 percent and 12 percent respectively.

26. This may be especially true for museums. Hilton Kramer has noted that 57 percent of all museum staff are volunteers; "On Museum Volunteers," *New York Times*, 29 June 1975, p. 37. Gallup, 1986, p. 43, emphasizes that 55 percent of all volunteers also contribute; specifically, arts contributions come from only 4 percent of nonvolunteers, but from 12 percent of volunteers. However, baby-boomers who volunteered also contributed sizably in only two-thirds the proportion of their volunteering elders.

27. The possibility of declining congressional support for the arts is explored in *Congress and the Arts: a Precarious Balance?* Margaret J. Wyszomirski, ed. (New York: American Council for the Arts, 1988).

28. Blau, 1986; Robinson, 1986.

29. Easterlin, 1987; Joshua Meyerowitz: *No Sense of Place* (New York: Oxford University Press, 1985); Richard A. Peterson, "The Me Generation as Arts Audience," presented at the Annual Conference on Social

Theory, Politics, and the Arts, Washington, D.C., 1988; Meg Cox, "'New Age' Music Wins Wider Following as Many People Grow Too Old for Rock," *Wall St. Journal*, 1 April 1987, p. 31.

30. "The Avant-Garde: Moving from Cult to the Mainstream," and "International Network Nourishes Avant-Garde," *New York Times* 27 July 1987, p. C15, and 28 July 1987, p. C16.

31. Charles Newman, "What's Left Out of Literature," *New York Times Book Review*, 12 July 1987, VII, p. 24.

32. James Sloan Allen, *The Romance of Commerce and Culture* (Chicago: University of Chicago Press, 1983).

33. Robinson, 1986, p. 13.

34. David Cwi, "The Arts Surveyed," *American Arts*, March 1984, pp. 12-15.

35. Judith H. Balfe, "Artworks as Symbols in International Politics," *Politics, Culture, & Society* 1, no. 2 (1987): 5-27. Leslie Savan, "The Arts Festival That Ate New York: a Tale of Commerce and Culture," *The Village Voice*, 14 June 1988, p. 25, notes the expansion of American Express' 1981 "cause-related marketing" to "perk marketing" for the 1988 New York International Festival of the Arts.

36. Margaret J. Wyszomirski and Judith H. Balfe, "Coalition Theory and American Ballet Theater," *Art, Ideology, & Politics*, Balfe & Wyszomirski, 1985, pp. 210-36.

37. Hodgkinson and Weitzman for Yankelovich, 1986, p. 22.

38. Case studies of successful efforts to take the arts into the workplace are reported in Balfe and Heine, eds., 1988. Attracting and keeping new audiences through greater efforts in arts education are emphasized by Bradley G. Morison and Julie Gordon Dalgleish, *Waiting in the Wings* (New York: American Council for the Arts), 1988.

39. Ann Swidler, "Culture in Action: Symbols and Strategies," *American Sociological Review* 51 (1986): 273-86.

UNDERSTANDING FOUNDATION POLICY CHOICES AND DECISION-MAKING PROCEDURES

by Pat Clubb

Private foundations are of major concern to nonprofit arts organizations for several reasons. First, foundations have made a vital contribution to the growth and development of the arts in all regions of the United States, particularly during the post-World War II era. This contribution has been largely financial in nature, in keeping with the primary function of foundations. In recent years, *Giving USA* has proved to be the most reliable source of information concerning private contributions to the arts. It reported that foundations contributed 5.9 percent or $5.17 billion of all donated funds in 1987. The arts, culture and humanities received 6.7 percent ($5.83 billion) of all funds contributed to the nonprofit sector. In 1987, the share of philanthropic giving to the arts rose slightly to 6.84 percent of total contributions ($6.41 billion).[1] Looking only at foundations, *The Foundation Grants Index* reported contributions of $388.5 million to cultural activities in 1987. This estimate is based on a sampling of the grants awarded by 459 foundations and therefore under-reports total foundation giving to the arts.[2]

Although support has been significant, financial contributions by foundations have not been characterized by trends or patterns that exhibit long-term income stability for the arts industry.[3] Patterns of giving by foundations are often characterized by large annual donations to particular arts organizations with no guarantee or even reasonable expectation that the contribution will be forthcoming in future years. Foundations have maintained, as have other private sector donors, an independence from their grantees which leaves arts organizations relatively vulnerable in the process of budget planning.

Further, since foundations are relatively free of many of the constraints that inhibit corporate giving, they have the option of fostering or promoting particular areas of need within the arts industry which may not be favored

by other donors. However, Paul DiMaggio points out that foundations tend not to be risk takers in their funding decisions and have not played a major role in supporting the less traditional areas of the arts industry, such as experimental arts organizations, individual artists and others.[4] The fact that foundations have chosen not to take advantage of this relatively unique opportunity is one of the concerns of this study. As the decision-making processes of foundations are examined more closely, it will become more apparent why this is true.

No one would argue that foundations are not critical to the financial health of the nonprofit sector. Unlike corporations or private donors, the primary function of foundations is to contribute financial support to organizations that are charitable in purpose or provide a public service. Uniquely American, this system allows the foundation to establish and implement public policy through its function as a financier of public goods. Whether foundations actually make explicit public policy decisions and then attempt to implement them is, however, unclear.

Little is known about the foundation community. Insular by tradition, these donors have escaped close scrutiny as to their objectives, decision-making processes, procedures of accountability and long-term community-wide effects. Unlike corporate donors and government funding sources, they do not require the exposure demanded by market considerations or receive the attention generated by the requirements of accountability. In fact, it appears that foundations perceive it to be in their best interest to remain relatively unnoticed within the donor community. Foundations have no strong incentives to demand recognition for the policies they adopt and the subsequent funding decisions they make.

As a result of their low profile, foundations have been given only marginal consideration as subjects of research. This has occurred not only from a specialized subsector perspective — i.e. arts, education, human services — but also from the concerns of public policy in general. Yet research efforts are important for several reasons. Foundations play a highly influential role, albeit small in its dollar impact, in setting the public policy agenda. In addition, nonprofit organizations require quality research in order to develop competitive fundraising strategies. Such strategies must be based upon a broad perspective of how each type of donor makes decisions. This means that foundation behavior must be understood not only as it relates to the arts or a particular subsector but also as a general response to the collective nonprofit community.

FOUNDATIONS AND POLICY

Agendas are not uniform in nature across policy areas or agencies; in fact, agendas take many forms and are constructed from a variety of influences. It is important to know whether the foundation generates its agenda internally or if instead its agenda is the result of external factors, or both. Internally generated agendas are those based on the goals and objectives of the trustees. They are likely to be implicit in form, focus on specific non-profit organizations rather than nonprofit issues and exhibit only marginal, conservative changes over time. Externally influenced agendas are those expected to be explicit in form, focus on polices or issues, exhibit considerable staff as well as trustee influence and respond to broader community needs. Although they may exhibit marginal change, they also have the potential for radical change.

The decision-making procedures adopted by foundations are expected to reinforce their agenda-setting styles. That is, foundations with implicit agendas are expected to have decision-making processes that exhibit high levels of trustee control, informal application procedures and low levels of interaction with the community, including potential recipients of foundation funds. Traditional, well-established arts organizations would be favored by these foundations. Foundations with explicit agendas are expected to exhibit somewhat the reverse of these characteristics. That is, they are likely to respond more favorably to the alternative type of arts organization (avant-garde programming, cultural diversity and so forth). A highly professional staff, formal application procedures and awareness of community or industry needs could potentially move these foundations away from the established, major arts institution as the exclusively favored grantee.

In practice, few foundations will be clearly defined by either of the models just described, but by a combination of the two. This study of foundation agenda-setting styles, decision-making procedures and funding decision outcomes will center on two major questions:

1. Do foundations set explicit policy agendas? And, if so,

2. What types of decision-making procedures do foundations adopt in order to carry out their policy agendas.

THE FOUNDATION COMMUNITY

As a means of attaining a descriptive profile of the foundation community and of assessing the questions raised above, a mail questionnaire was sent to a sample of 400 national foundations during the summer of

1987.[5] A 42.8 percent response rate — 171 returned, usable questionnaires — lends support to the findings. Table 1 presents basic descriptive statistics on the foundations which responded.

Foundation Assets. The majority of foundations (67.9 percent) are small, reporting assets of $15 million or less. Large foundations — those with assets of $15 million or more — comprise a much smaller percentage (33.1 percent) of this donor community. Furthermore, of the large foundations, 69.3 percent fall into the *upper range* of the scale — more than $50 million. From this skewed distribution it can be concluded that, in terms of assets, foundations tend to be either relatively small or extremely large.

Although there may be important differences between large and small foundations, these are not the focus of this study because foundation size is not necessarily correlated with explicitness of policy goals. It is expected that foundations engage in developing policy goals and objectives within the constraints set by budget limitations, but there is no reason to assume that budget size is the motivating factor behind the process of agenda setting. No responsible student of public policy would suggest that agencies with large budgets are more deliberate in their efforts to establish policy than their agency counterparts with smaller budgets.

Staffing. Only 16 percent of the foundations responding report five or more full-time staff members. The average number of full-time staff for all foundations is two, with 76.9 percent of the foundations surveyed reporting zero to one part-time staff members. From these data we can conclude that foundations tend to operate with minimal staff. However, no findings suggest that foundations do not employ adequate staff for their needs.

Trustees. Of those foundations responding, 87.6 percent reported having 10 or fewer trustees. If trustees control the majority of foundation funding decisions, this small number suggests a rather large ratio between the dollars allocated and the degree of individual trustee influence over decisions, but there is little hard evidence to support this claim. Nevertheless, the assertion must be considered because of the questions it raises concerning the degree of influence trustees exercise over foundation policy. At the same time, there may be factors which intercede to alter the level of influence trustees appear to have over the establishment of foundation agendas.

The degree of homogeneity within the trustee community would tend to increase the ratio. To the extent that a high level of homogeneity is found among foundation trustees, the degree of influence held by an individual trustee in making decisions is increased.[6] This assumes that homogeneity

within a group will result in like decisions, and that trustee decisions reinforce other foundation trustee decisions with few competing positions on the overall funding patterns of this group of donors.

However, the decision-making process employed by individual foundations may restrict the amount of power held by trustees in determining which organizations receive grants and for how much. Those processes that are relatively accessible and depend on enforced guidelines and regulations might tend to decrease trustee control over the final decisions.

The relationship between the decision-making power of individual trustees and funding dollars is important in understanding donor organizations because it focuses attention on the underlying source of foundation policy. It clearly suggests that the trustee ultimately controls foundation policies and subsequent funding decisions. Therefore, the strategy of applicant organizations must recognize this in terms of both requesting support for individual organizations and achieving longer-term goals such a promoting a certain subsector for foundation support — for example, the arts.

Year and Type of Incorporation. An important finding from these data is that 78.4 percent of the foundations surveyed were incorporated after 1945, which suggests that foundations as a donor group have been defined

TABLE 1: Foundation Community Profile

Percentage of Foundations (n = 171)

Assets of Foundations (in Millions)	
Less than $1m	12.6%
$1m to $5m	40.7
$5m to $15m	13.6
$15m to $50m	9.9
Over $50m	23.2
	100.0%

Number of Full-time Staff	
0-1	54.4%
2-4	29.1
5-over	16.5
	100.0%

Number of Part-time Staff	
0-1	76.9%
2-4	23.1
5-over	0.0
	100.0%

Number of Trustees	
1-5	41.3%
6-10	46.3
11-15	8.6
15-over	3.8
	100.0%

Year of Incorporation	
Before 1900	0.0%
1901-1944	21.6
1945-present	78.4
	100.0%

Incorporation Type	
Corporate	39.5%
Community	0.0
Private	60.5
	100.0%

Explicit Policy Agenda	
Yes	48.1%
No	46.8
Not Sure	5.1
	100.0%

by post-World War II developments. Because foundations are relatively recent, data to measure their impact, characterize their structure and draw conclusions about their goals and objectives are not abundant. For example, this study is severely limited because the data are not longitudinal and offer only a brief cross-section of the foundation community. A more complete study of foundations will be possible when longitudinal data are collected and assessed over time.

Of the foundations surveyed, 39.5 percent were corporate foundations, none were community (this is not surprising considering the small total number of community foundations) and 60.5 percent were private. Although foundation type did not significantly affect the characteristics examined in this survey, in some aspects these three foundation types would be found to be significantly different. However, those concerns are outside the scope of this study except where noted.

Type of Policy Agenda. Finally, these data reveal that 48.1 percent of the foundations responding claim to set explicit policy agendas. Agendas defined by this study as implicit were chosen by 46.8 percent of the respondents, and 5.1 percent were not sure. An introductory explanatory statement was included with the questionnaire to make clear how the terms *explicit policy* and *implicit policy* were to be used by the respondent. An explicit policy agenda is defined as a deliberate attempt to establish measurable goals and objectives and subsequently to make a series of funding decisions to achieve those goals and objectives. These policy goals and objectives may or may not be assigned priorities. An implicit agenda is driven by the collective funding decisions made by the foundation throughout the year. These decisions do not reflect predetermined goals and objectives of the foundation but rather are made independently of such considerations.

Before examining foundation agenda setting in more detail, it should again be noted that clearly the two styles of agenda-setting are not distinct. Thus it is not altogether accurate to describe implicit or explicit agendas as models. Rather the analysis will examine each style to determine if these approaches to decision making can be considered significantly different for the purposes of understanding foundation behavior.

AGENDA-SETTING BY FOUNDATIONS
Explicit Agendas

Of the foundations responding, 48.1 percent claimed to set explicit policy agendas. Table 2 reports findings that are applicable to this group of foundations.

Among foundations that have explicit policy agendas, 50.1 percent have policies set by trustees. A small percentage, 2.6 percent, have staff-set policies, with the remaining 44.7 percent setting policy by trustees in collaboration with staff. Certainly the role of the trustee is critical in the agenda-setting process.

Foundation policy for this group tends to be in written form, which supports the suggestion of a formal agenda structure. Only a small percentage (20.0 percent) verbally communicate policy decisions, and an even smaller percentage (11.4 percent) uses informal methods. Although the communication of policy tends to be structured, the setting of policy is done regularly by only 44.4 percent of this group. Policy is set at random by 38.9 percent of these foundations, with a mixture of these approaches used by 16.7 percent.

Policy change, when it occurs, tends to be defined as radical by only 8.1 percent of the foundations. Most policy is changed only marginally, as would be expected; that is, there is nothing about this institutional type, except for the lack of constraints, to suggest that change would occur other than incrementally. However, foundations have not taken advantage of the opportunity to make radical or high-risk decisions.

Setting policy priorities is an important policy characteristic for several reasons. First, it denotes a certain level of sophistication in terms of allocating resources in order to establish goals. Setting policy priorities is generally thought to occur in most public policy institutions. Second, setting priorities lends support to the seriousness of the agenda effort by adhering to

TABLE 2: Explicit Policy Characteristics
Percentage of Foundations (n = 71)

Who sets policy:	
Trustees	50.1%
Staff	2.6
Trustees with staff	44.7
Other	2.6
	100.0%

Policy is communicated:	
Written	68.6%
Verbal	20.0
Informally understood	11.4
	100.0%

Policy is set:	
Regularly	44.4%
Irregularly	38.9
Other	16.7
	100.0%

Policy change is:	
Radical	8.1%
Marginal	67.6
Other	24.3
	100.0%

Policy is prioritized:	
Yes	47.4%
No	50.0
Other	2.6
	100.0%

Funding follows priorities (n = 34):	
Always	33.7
Sometimes	53.0
Don't know	13.3
	100.0%

decision-making standards when resources are being allocated within a competitive process. On this issue, only 47.4 percent stated that policy priorities are set, and of those only 33.7 percent stated that the subsequent dollar decisions followed the established priorities. These data imply that where policy is formally established and communicated, it tends not to have set priorities which are funded according to priority guidelines. However, these findings may reflect a problem caused by the source of the data. Of the explicit policy group, only 2.2 percent of the returned questionnaires were filled out by trustees, and yet we know that policy is set almost exclusively at the trustee level. The process of setting priorities and assigning dollar amounts to applications that reflect priorities may be occurring, but it probably occurs in the trustee arena where it is hard to detect.

Additionally, earlier studies indicate that foundations give preference to established organizations in their funding decisions. Therefore, priorities may be set at the organizational level and not the policy level. In other words, a foundation might put equal emphasis on several nonprofit subsectors but set priorities according to the applicant organizations within each. For example, the arts, health and education may not be assigned priorities as policy concerns, but the local symphony, hospital and local college may be ranked according to foundation preference.

These findings set the stage for the final section of the analysis. Is there a significant difference among foundations between explicit and implicit agenda-setting styles and their corresponding procedures? The reader will find it helpful in considering the data and discussion that follow to know that the answer to this question is a definite *no*. Because the differences between the explicit and implicit policy groups are not statistically significant, these differences can only be explained as random. While the reader should not dismiss the idea of explicit and implicit policy approaches to foundations, it is more important to focus on the distribution of the responses from the total group across the options offered.

Because the differences between the two groups of foundations are random, the following tables report the data collected from the total group of foundations which responded. These data have high confidence intervals; that is, distributions represent a close facsimile of those found in the foundation community as a whole. In other words, there are not two distinct groups defined by agenda-setting style within the foundation community. However, these data give an excellent profile of the foundation community as a singular body in terms of policy and decision-making procedures.

Characteristics of Agenda Setting

The data from Table 3 report the percentage of foundations that chose each of the items as their first or second choice in a rank ordering. Only 21.2 percent of the foundations chose community problems as important in setting policy, although 42.7 percent chose applicant visits to the foundation trustees as important and 37.4 chose applicant visits to foundation staff as important. Additionally, appeals from community leaders were chosen by 37.1 percent as being important in setting policy objectives. The implications are that pressure exerted on trustees and/or staff by applicants, including community leaders, may be an effective strategy but not within the perspective of community problems.

Furthermore, it is not clear from these data how or if a foundation decision maker considers the issues or problems of his/her community. Although it is assumed that persons associated with a public service funding institution have some sensitivity to community issues, the data reveal that community awareness does not translate into foundation policy for a large percentage of foundations. Appeals from community leaders had a significantly higher impact on the setting of foundation policy, but because community problems ranked low it can be concluded that the appeals from community leaders are not problem-oriented. Therefore, they may be organization-oriented, an assumption that is not inconsistent with the findings of the studies mentioned earlier.[7]

TABLE 3: Agenda-setting Characteristics

Percentage of Foundations (n = 171)

Policy objectives are set as the result of:	
Community problems	21.2%
Applicant visits to trustees	42.7
Applicant visits to staff	37.4
Appeals from community leaders	37.1
Interests of trustees	44.2
Interests of staff	30.1
Foundation tradition	17.3
Other	-
Foundation policy is characterized by:	
Problem solving	49.2
Stabilizing applicant organizations	43.1
Focusing on "alternative" organizations	34.9
Foundation's image	51.2

Within this group of foundations, 44.2 percent chose the interests of trustees and 30.1 percent chose the interests of staff as important in setting policy. Foundation tradition was chosen by only 17.3 percent as being important in the policy process.

As with any questionnaire, there are many unknowns. Staff and trustee policy interests are assumed to be relatively independent of the solicitation efforts involving staff and trustees. In other words, the staff and trustee interests are not a function of the applicant visits discussed above. Nominal or ordinal level data unfortunately do not lend themselves to sophisticated statistical testing or analysis. However, it can be concluded that no one item dominates the policy-setting process and all are somewhat important, with the exception of foundation tradition.

As to foundation policy characteristics, 49.2 percent chose problem solving as important. Focusing on alternative organizations was chosen by 34.9 percent of these foundations as being characteristic, while 43.1 percent chose the stabilization of applicant organizations as important. The most popular choice was policy directed to enhance the foundation's image.

These findings suggest that foundations set policy that is trustee oriented with some staff input. This arrangement appears to be directed somewhat toward community problems or problem solving and in addition does respond to personal contact with the applicant. Least characteristic of foundation policy is that which focuses on alternative organizations; policy characterized by a concern for the image of the foundation is found to be the most important. These data are limited in revealing how foundations define image, but from previous studies foundations are known to favor the established, more conservative institutions.[8] The frequency with which local symphonies are funded, for example, suggests a preference for foundation decisions based on relatively conservative approaches to community involvement. In analyzing these data, the most problematic finding is the apparent conflict between the high, positive response to foundation policy being characterized as "problem solving" and the low, positive response to policy objectives being set as the result of "community problems." One hypothesis is that an organizational orientation is again being exhibited on the part of foundations, rather than one of more broadly based policy concerns.

DECISION-MAKING PROCEDURES
Formal Structure

Organizations such as foundations or any institution that carries out its policies by funding other groups (in this case, nonprofit organizations) must consider decision-making procedures from the point of submission of ap-

plications for funds (including solicitation efforts) to the completion of the funded projects. Tables 4 and 5 report data on decision-making procedures. Because of the fundamental links between policy and implementation, many of the decision-making activities under consideration are not independent of the policy concerns. Implementation of policy for foundations is achieved through funding decisions, and these decisions are achieved through measurable processes.

According to Table 4, the hierarchical model, which includes the executive director of the foundation, was the most favored (28.4 percent). In this model the chair of the trustees has no more authority than the other trustees. The most favored lateral model including the chair and the trustees was chosen by 12.3 percent of the respondents. From these results, it can be concluded that over half, 52.2 percent, of foundations include the executive director in the decision-making structure with the total group of respondents (not including the 11.2 percent which chose "none apply") employing formal decision-making structures that are dominated by trustees.

Foundations favor the "trustees including the chair" method of final approval. Few foundations, 15.2 percent, favor the method of "trustees including the staff" in making final decisions, with only slightly more, 14.0 percent, giving final authority to the chair of the trustees. Foundations favor a majority vote, with 45.8 percent choosing this method. Implied consensus was the second choice, 28.9 percent, with "unanimous vote" the method least employed.

Application forms are used by only 16.2 percent of foundations. Although application forms are not favored by most foundations, 57.3 percent claim to operate under printed guidelines.

In terms of how they view their decision-making procedures, 48.3 percent of foundations described their process as formal. However, the foundations claimed that if their process was formal, adherence to the structure was moderately strict to not strict.

Table 5 reports data concerning activities which, though related to the decision-making process, can be considered peripheral to the more formal structure.

In terms of soliciting applications, 59.0 percent chose word-of-mouth in the community. This finding gives some support to the local orientation perceived by many as describing foundation behavior.[9] Foundations tend not to use promotion, a decision that could be a function of supply and demand or could reflect the insular tradition of foundations.

TABLE 4: Formal Decision-Making Structure

Percentage of Foundations (n = 171)

Decision-making Models[8]

#1 Chairperson	22.7%
Trustees	
#2 Chairperson-Trustees	28.4
Executive Director	
#3 Chairperson	17.4
Trustees	
Executive Director	
#4 Chairperson-Trustee-Exec. Director	6.4
#5 Chairperson	1.6
#6 Chairperson-Trustees	12.3
#7 None apply	11.2
	100.0

Final Authority over Decisions

Chair of Trustees	14.0
Trustees Including Chair	69.2
Staff	-
Trustees and Staff	15.2
Other	1.6
	100.0

Method of Decision

Majority Vote	45.8
One-person Decision	7.2
Unanimous Vote	12.3
Implied Consensus	28.9
Other	5.8
	100.0

Formal Application

Yes	16.2
No	83.8
	100.0

Printed Guideline

Yes	57.3
No	42.7
	100.0

Decision-making Process

Formal	48.3
Informal	49.0
Don't Know	2.7
	100.0

If Formal, Adherence Is (n = 83)

Very Strict	7.3
Strict	23.4
Moderately Strict	62.1
Not Strict	7.2
	100.0

TABLE 5: Activities Related to Decision-Making

Percentage of Foundations (n = 171)

Major Stimuli for Submission

Solicitation by Staff	16.2
Solicitation by Trustees	19.2
Word-of-Mouth in Community	59.0
Promotional Efforts by Foundation	13.0
Foundation Reference Sources	57.9
Other	12.1

Activities by Staff During Process

Solicitation of Information	81.3
Visiting an Applicant	56.8
Rejection of Application Before Trustee Action	69.2
Recommendation to Trustees for Approval	51.3
Recommendation to Trustees for Dollars	64.2
Recommendation to Trustees for Rejection	49.3

Written Report Required of Funded Applicants

Yes	34.2
No	37.5
Sometimes	26.1

Use of Written Reports

Future Funding Decisions for That Applicant	42.6
Future Funding Decisions for Similar Projects	25.2
Satisfy a Foundation Legal Requirement	29.3
Basis for Future Policy Decisions	26.7

Visit by Staff During Funded Projects

Always	7.1
Only if Invited	11.9
Never	16.9
Sometimes	61.6

As far as activities undertaken by staff during the decision-making process, 81.3 percent of the foundations say their staff solicits information, and 56.8 percent indicate staff visits applicants. Staff influence may be at its highest during that part of the process which allows staff to reject an application. Occurring before trustee action, 69.2 percent of the respondents claimed this to describe their decision-making procedure. The implications of this to applicant organizations should be obvious.

Written reports from funded applicants are required by 34.2 percent of the respondents with 37.5 percent indicating written reports are not required. For those that do require a report, foundations tend to use these

more often to judge the same applicant on future requests. Only 26.7 percent claimed that written reports were used as the basis for future policy decisions. However, 42.6 percent claimed to use written reports in making future funding decisions for those specific organizations, reinforcing the notion that an organizational rather than a policy orientation characterizes foundation decisions.

Foundations visit an applicant only sometimes. If it is correct to assume a local bias in foundation giving, then by not visiting successful applicants, foundations may be missing a valuable opportunity to assess the funded project.

The limited resources of arts organizations demand that the ratio between applications submitted and those funded be as small as possible. If an organization knows that trustees make the final decisions but that most foundations allow staff to reject an application before action is taken by trustees, communication between the applicant and the foundation staff obviously is important — a finding that applicants should find useful. However, if the findings discussed above are considered by applicant organizations as a means to ensure success with foundations, then disappointment is guaranteed. We are a long way from understanding how to narrow the odds for applicant organizations within the decision-making processes of foundations. What the findings can do is to give a subtle understanding of how foundations operate and, equally important, verify that much of what is believed about foundations is indeed true.

CONCLUSIONS

This piece of research on foundations has begun a process that I hope will lead to the development of more accurate models by which we can better understand foundation behavior and funding decisions. In this review of the current survey's findings, two major areas will be discussed: first, what emerged as important about the foundation community as a whole and, second, the hypothesis that there exists within the foundation community an explicit policy-setting group and an implicit policy-setting group.

The majority of foundations are private and were incorporated after 1945. Less than half of the foundations are large according to the definition used by this study; rather, in terms of the available funds at their disposal for distribution to applicants, most foundations are relatively small. As a result, despite the lack of a measurable standard concerning the ratio of staff size to budget, there appears to be a small average staff size for this donor community.

Throughout the analysis, trustee influence was seen as overwhelming most aspects of the decision-making process of all foundations. Characteristics that might counter this influence were not observed as being significant to the procedures employed by most foundations. Very few require application forms and many describe their processes as informal in structure. Requests for funds tend to be submitted as a result of "word-of-mouth" within the community, and most funded applicants are not required to submit a written final report. Most funded applicants are not visited by the staff, a finding that raises several issues – for example, the level of communication between the funded applicant and the donor, and the basis on which the applicant may or may not be funded in the future. All of these findings lend support to the suggestion that foundations tend to be organization-oriented, not issue-oriented, in their decisions.

These findings also suggest that applicant organizations need to establish a positive organizational image within the donor community. An organization with a clear direction and purpose in addition to high organizational operating standards is more advantageously positioned to receive support than an organization that has ignored these factors.

It is important to understand why and how foundations make decisions. Because they make public policy based on the distribution of their grant funds, it is not unreasonable to assume that for many of these donors this exercise is conscious and deliberate. This group has been labeled the explicit group, whereas those foundations making policy simply by their funding decisions are called the implicit group. The study has found no evidence to support the existence of two such defined groups of foundations within this donor community. Both groups operate almost identically in terms of policy agenda setting, policy characteristics and decision-making procedures. These findings are nonetheless valuable because they make possible a fairly composite view of the foundation community as a whole.

Because this study has determined that foundations do not set explicit policy agendas as defined here, applicant arts organizations must consider the implications of the homogeneous nature of the foundation community. Foundation policy appears not to reflect well-articulated needs arising from the arts community, and until it does, decisions for funding will be based primarily on the reputations of individual organizations. Although this policy is not necessarily problematic for the recipient organizations, it does not always promote a decision-making environment that can efficiently meet the broader needs of the arts industry.

Two final points need to be made in reference to foundations. First, even considering the proliferation of public agencies beginning with the New

Deal and continuing through the Great Society (some would say through the present), in comparison foundations are relatively new on the public policy scene. Further, public agencies, regardless of age, have emerged from a system of government that is several centuries old, a statement that cannot be made of foundations.

Second, most foundations, unlike other donors, have little potential for growth. This is an issue which can only be addressed by empirical evidence; however, there is little to suggest that foundation budgets will increase. Only those few that are structured to reinvest a large portion of their income can anticipate significant increases in their assets. Therefore, it can be predicted that growth in this sector will occur only as new foundations are created. This is problematic for arts organizations in the sense that efforts designed to heighten the foundation community's awareness of the needs of the arts industry must successfully reach the new as well as the established members of this donor community. This goal is not unique to foundations — corporate and private donors also exhibit this characteristic — but it is an important one, and it is not always considered in the long-range promotional plans of arts organizations.

Why are these findings important to nonprofit arts organizations? If foundations are to play as effective a role as possible in enhancing the health of the arts industry, funding decisions should emerge from a set of explicit policy goals established and articulated by each foundation. These goals are best developed through an ongoing dialogue between the arts industry and the foundations. This is an ideal that so far has not been satisfactorily achieved by the public sector, but only by striving toward it can the arts industry hope to make foundation decisions more reflective of the broad issues and concerns of the arts community as a whole.

Finally, foundations have played a major role in developing the arts in this country. As contributed revenues from all donors expand and shrink over time, it is important to maximize the potential positive effect of donor contributions to this industry. Foundations appear to be adhering to responsible positions in terms of their funding decisions. This trend does not imply, however, that the decision-making and agenda-setting procedures of donors to the nonprofit sector cannot be approved.

NOTES

1. American Association of Fund-Raising Counsel, *Giving USA:* Annual Report 1987 (New York: American Association of Fund Raising Counsel, 1987), 2-9.

2. The Foundation Center, *The Foundation Grants Index,* (New York: Foundation Center, 1988).

3. Pat Clubb, "An Analysis of the Economic Instability of Arts Organizations," *The Journal of Arts Management and Law* 17, no. 1 (Spring, 1987): 47-74.

4. Paul DiMaggio, "Support for the Arts from Independent Foundations," *Nonprofit Enterprises in the Arts,* in Paul DiMaggio, Ed. (New York, New York: Oxford University Press, 1986): 113-139.

5. The questionnaire was mailed to 400 foundations whose names were drawn as a random sample from *The Foundation Directory.* The questionnaire was six pages of questions with only one being open-ended. The questions utilized rank ordering, dichotomous choices, and 5- and 7-point Likert scales. The questions were designed to gather data concerning two primary areas: policy agenda-setting and decision-making processes. Every attempt was made to use a neutral vocabulary throughout the instrument with special attention paid to the questions dealing with trustee control. The author would be happy to make the instrument available upon request.

6. The claim of homogeneity among trustees is supported by Paul DiMaggio, 1986, op. cit. 132-133. DiMaggio further describes this homogeneity as conservative in nature.

7. DiMaggio, 1986, op. cit.

8. The decision-making models offered as choices were of two primary types: lateral and hierarchical. Both types incorporated the chairperson of the trustees, trustees, staff and executive director in various configurations of the two models. Examples of the variations would be the chairperson having greater decision-making authority than the other trustees, equal decision-making authority with the other trustees; and similarly, the positions of authority of the executive director in relationship to his/her staff.

9. This finding provides data which help explain the cause of the non-risk character of foundation decisions. These data clearly support trustee influence over foundation policy and funding decisions. This is consistent with the finding that alternative organizations are not favored, which is in keeping with DiMaggio's claim of the conservative nature of foundation trustees. DiMaggio, 1986, op. cit.

CORPORATE SUPPORT FOR CULTURE AND THE ARTS

By Michael Useem

Corporate support for nonprofit organizations is approaching $5 billion annually. Company underwriting of culture and the arts has kept pace as well, reaching an annual level of more than $500 million by 1986. Though arts giving rarely constitutes more than 20 percent of a firm's giving budget, most major firms contribute at least some support to culture. The widespread backing of the arts stands in sharp contrast to the picture just a decade earlier, when annual giving totaled little more than $100 million.

The rise of business giving has been driven in part by a more general intensification of corporate interest in community and public affairs during the 1970s and early 1980s. Prior to this era, many managers had adhered to a philosophy that stressed "sticking to business" and avoiding the media, but during the 1970s a managerial culture emerged that, by contrast, emphasized outreach and openness. Fearing increasing political isolation in a period of public disenchantment with established institutions, major corporations enlarged their public affairs operations, by opening Washington offices, creating political action committees, encouraging their managers to participate in community affairs and, not least, expanding their giving budgets.[1]

The act of corporate giving consequently acquired a more central place in the corporation's strategic thinking. Although a company's giving budget still constitutes a tiny fraction of its overall budget, the giving function is now frequently featured as the centerpiece of a firm's efforts to serve the community. Moreover, corporations are more often approaching the contributions effort in the same disciplined fashion as they apply to other areas of company decision-making. They are moving toward a "more market-driven strategic-management, bottom-line approach to philanthropy," report two company observes, "to obtain a tangible return for their contributions."[2]

Although the professionalization of the giving function may have diminished the importance of altruism in company contributions, recent research has indicated that giving has not been fully harnessed by market considerations. Nonmarket institutional factors, such as a firm's size and leadership commitment, remain important as well. Corporate support for the arts continues to be a blend of market and institutional considerations, with both shaping a company's giving program.

Market and institutional factors are important determinants of not only the overall level of a company's annual contributions budget, but also the company's budget allocations among the major fields of nonprofit activity. The allocations are now generally classified by the Conference Board and other organizations that track corporate giving into four major areas: (1) education, receiving 38 percent of a company's giving budget on average in 1986; (2) health and human services, 29 percent; (3) culture and the arts, 12 percent; and (4) civic and community activities, 11 percent. The precise allocation of funds among these major areas, however, varies considerably from firm to firm, with both market and institutional factors explaining much of the difference. The two factors can be important as well in shaping a third level of company decision making: selecting the arts applicants that are deserving of support.[3]

MARKET FACTORS IN CORPORATE CONTRIBUTION

The single most important market factor behind corporate giving is a company's income. Corporations with higher earnings give away more money. This linkage is a product of the way large firms generally fix their contributions level. The size of the budget is typically keyed to the previous year's income before taxes. During the 1970s, corporations allocated, on average, about 1 percent of their pretax net income to nonprofit causes. During the early and mid-1980s, however, the 1 percent convention was replaced by a 2 percent rule, indicative of the increased importance of corporate giving (Table 1). Thus, when a firm's pretax profits rose by $1 million, its contributions budget the following year was likely to rise by about 2 percent, or $20,000. When a bad year followed a good one, the contributions budget was likely to fall by a corresponding amount. More generally, in periods of strong economic growth, the aggregate amount of corporate giving can be expected to increase by a proportional amount, whereas weaker periods should bring the reverse.

The almost negligible growth in corporate giving between 1985 and 1986 can be traced largely to a slowdown in corporate earnings, rather than any fundamental restructuring of company priorities. If it is assumed that com-

TABLE 1: Total Corporate Contributions, and Contributions to the Arts, 1975-86

Year	Total Contributions ($Billions)	Contributions as Percentage of Pretax Net Income	Percentage of Total Contributions Given to the Arts	Estimated Amount Given to the Arts ($Millions)
1975	$1.20	0.91%	7.5%	$90
1976	1.49	0.89	8.2	122
1977	1.79	0.89	9.0	161
1978	2.08	0.89	10.1	211
1979	2.29	0.89	9.9	227
1980	2.36	0.99	10.9	257
1981	2.51	1.11	11.9	299
1982	2.91	1.71	11.4	331
1983	3.63	1.75	11.4	413
1984	4.06	1.69	10.7	434
1985	4.40	1.96	11.1	488
1986	4.50	1.94	11.9	536

Source: Conference Board, Annual Survey of Corporate Contributions, 1987 Edition (New York: Conference Board, 1987), p. 27; Survey of Corporate Contributions, 1988 Edition (New York: Conference Board, 1988), p. 35.

pany earnings will resume their upward movement in the years ahead, both overall corporate giving and gifts to the arts should recover their upward movement as well. The rate of upward movement, however, could be slowed if the percentage of pretax net income allocated to giving drops from its historic high—nearly 2 percent in 1985-86—as could well happen during the late 1980s.

Company giving to the arts has followed much the same curve, though in recent years the arts have fared better than other areas of business support. Between 1975 and 1986, the total amount of corporate giving displayed an approximately fourfold increase, while the aggregate amount of arts giving showed a sixfold increase. Less than 10 percent of the typical company's contributions budget went to the arts in the 1970s, but on average nearly 12 percent or more was allocated in the 1980s (shown in the third column of Table 1). When a company achieved an earnings growth of $1 million, arts organizations could therefore anticipate a rise in the firm's cultural budget of approximately $2,300, a product of the arts' 12 percent share (1986) of the 1.9 percent pretax net income.

The driving importance of company earnings can be seen in the fortunes of the Polaroid Foundation, the contributions arm of Polaroid Corporation. Ranking 211th on the 1986 *Fortune 500* listing, Polaroid had annual sales of

$1.8 billion and a pretax net income of $135 million that year, and the foundation oversaw a giving budget in 1986 of $1.9 million. In 1985, the foundation had absorbed a 5 percent cut as part of company-wide cost reduction measures brought on by slack sales. But 1986 was a far better year, with a sharp increase in earnings spurred by the new instant photography product, the Spectra System, and the foundation budget had been increased by 6 percent. In 1987 the foundation's budget was increased by an additional 10 percent, bringing annual giving to more than $2.1 million.

The overall picture of corporate contributions in 1986 was hovering around four benchmark round numbers: 2, 5, 10, and 500. Some 2 percent of pretax net corporate income was given to nonprofit organizations, for an annual aggregate total that is approaching $5 billion. About 10 percent of the contributions dollar was allocated to arts organizations, for an annual total near $500 million.

Corporate giving is more than a passive product of business success. It is used to stimulate income as well. For instance, studies of advertising and customer service expenditures reveal a substantial correlation with the size of the company's contributions budget, implying that giving is used as an indirect form of marketing. Similarly, studies of interindustry variations in rates of spending on advertising and philanthropy reveal high correlations, again suggesting that contributions are partly driven by marketing strategy. This control is manifest, for example, in the decision of some companies to underwrite major art exhibits, expensive sponsorships intended to heighten significantly a company's public visibility.[4]

Market considerations are also evident in the varying emphases placed on giving to the arts by companies in different product areas. Industries with direct public contact, such as insurance, retail and lodging, operate comparatively large advertising and contributions programs, while industries with little public contact, such as mining, construction, and primary metals, run smaller programs in both areas.

The arts contributions of the Polaroid Corporation, which markets its photographic products to the general public, stood at 16 percent of the total giving budget in 1987, one third above the national corporate average of about 12 percent. Even then, the foundation's operating committee faced a proposal in 1987 from the allocations committee responsible for culture to increase its share of the company's annual giving budget to 19 percent. The increase was questioned by those protective of Polaroid's strong commitment to supporting community and education programs, but after lengthy debate, the Polaroid operating committee moved to increase culture's share

to 17.5 percent, short of the initially proposed 19 percent but a substantial increase nonetheless.

A company's product sector generally is a strong predictor of its relative interest in the arts. The typical manufacturing firm allocates slightly less of its budget to the arts, 10.3 percent in 1986, than does the typical service company, which sets aside 15.9 percent. Service companies sell directly to the public more often than do manufacturing companies, and sponsorship of the arts may generate greater visibility than the underwriting of other areas, particularly among more affluent potential customers.

Industry variations within the manufacturing and service divisions are also substantial, as can be seen in Table 2 (which presents examples of product sectors whose relative contributions are high and low). The printing/publishing and retail industries, for instance, have generally given above-average proportions to the arts, while the chemical and pharmaceutical industries have given below-average amounts. Differences in market positions can explain some of the variation. Printing and publishing firms offer products that are central to American cultural life. Makers of electrical equipment, on the other hand, are more concerned with acquiring new research and a flow of scientists and engineers from the nation's college and univer-

TABLE 2: Percentage of Total Contributions to the Arts, by Selected Product Sector, 1984-86.

Product Sector	1984	1985	1986
Manufacturing, total	**10.7**	**9.9**	**10.3**
Stone, clay, and glass products	27.8	21.7	38.3
Printing and publishing	29.2	18.8	17.5
Petroleum and gas	13.3	13.4	13.5
Electrical machinery and equipment	11.1	8.4	8.9
Pharmaceuticals	7.4	6.7	7.3
Chemicals	6.2	6.3	6.4
Service, total	**10.7**	**14.0**	**15.9**
Retail and wholesale trade	15.5	18.9	20.0
Telecommunications	6.4	13.8	17.2
Banking	15.3	17.1	16.7
Finance	12.8	13.3	13.6
Insurance	7.3	9.8	13.1
Utilities	12.3	12.4	11.5
All companies, total	**10.7**	**11.1**	**11.9**

Source: Conference Board, Annual Survey of Corporate Contributions, 1986 Edition (New York: Conference Board, 1986), p. 45; Annual Survey of Corporate Contributions, 1987 Edition (New York: Conference Board, 1987), p. 46; Survey of Corporate Contributions, 1988 Edition, (New York: Conference Board, 1988), p. 56.

sities and thus tend to skew their giving toward education institutions. Polaroid Corporation's giving is a case in point, with many of its gifts closely related to its photographic products. The foundation sponsors museums across the country, such as the Museum of Fine Arts in Houston, in the acquisition of artists' photographs. Similarly, the marketing division has underwritten a PBS documentary on Yosemite and other national parks, intended to remind consumers of the link between natural beauty and instant photography.

Although more profitable companies make larger contributions, there is less certainty whether larger contributions make companies more profitable. Studies of the effect of giving on near-term earnings fail to confirm a favorable effect. Other research shows, however, that generous giving can increase a firm's reputation for social responsibility and even for being a well-run business, factors that can enhance a company's longer-term market position. One national survey, for instance, revealed that the public is aware that firms vary in social responsiveness, and that this perception correlates with the level of company giving. Another survey of executives, directors and financial analysts found that large manufacturing companies with proportionately larger giving budgets were regarded by the business community as exercising greater community responsibility. And a study of corporate giving in Minneapolis-St. Paul found that community leaders judged major corporate contributors to be not only more responsible companies, but better operated companies as well. The researcher concluded: "A reputation as a successful business appears to have been a function of either how much a company earned or how much it gave away."[5]

The intensification of "cause-related marketing" may tighten the relationship between giving and short-term earnings. This strategy was pioneered by American Express Company in a 1983 program to support the restoration of the Statue of Liberty. For every use of the American Express card, a penny was donated to the Statue Foundation, and for every new card application, a dollar was given, for a total of $1.7 million. The number of new cardholders increased by 45 percent during the promotion, and card usage was higher than had been expected, proving, in the words of two of the program's advocates, that "helping others also can be good business." The company also learned that its image as a socially responsible, even patriotic, firm was enhanced by the campaign, and it subsequently launched other cause-related efforts. To aid the elderly in New York City, for instance, American Express in 1987 initiated a program of donating money to Citymeals, an organization that brings hot meals to home-bound elderly residents. It committed ten cents to the meals program every time an

American Express cardholder used the card at a restaurant in New York City.[6]

INSTITUTIONAL FACTORS IN CORPORATE GIVING

Regardless of the extent to which corporate giving decisions are disciplined by concern for profitability, institutional factors have an independent impact on giving. The two most important institutional factors are a company's size and its leadership.

The Effects of Company Size

Larger firms contribute more money, regardless of the previous year's income; they give more uniformly near the 1 to 2 percent level (of pretax net income) and they allocate their funds in a more consistent way among the major groupings of nonprofit recipients. The driving force is professionalization: larger firms operate more formal programs, and their policies are more subject to the norms prevailing in the corporate community. However, the nation's largest corporations, whose pretax earnings can be in the billions, tend to give at a rate substantially lower than 2 percent of pretax net income, in part because the enormous contributions budget generated at that rate might prove *too* visible.[7]

With the advent of professional contributions managers, corporate giving programs tend to have an important impact upon one another. The contributions managers of major firms based in a metropolitan area frequently consult among themselves in considering applicants; if a large company has already funded a nonprofit organization, other companies are less reluctant to do so; and corporations do not want to be in a position of funding an organization about which the business community has its doubts. As a result, if an arts or other nonprofit organization acquires a favorable reputation among a few major corporate funders, its capacity to raise corporate money may snowball. The key to success can thus be the initial establishment of a beachhead within the corporate community. A national reputation among business donors is important, but even more salient for most nonprofit organizations is their standing within the local corporate world.[8]

Corporate acquisitions can make a major difference in corporate contributions, though the specific consequences depend on the particular firms involved. Because of the high concentration of company giving near headquarters (frequently more than 80 percent of the giving budget), a takeover often leads to loss of local support if the acquiring firm is located elsewhere. When Chevron Corporation of California bought Gulf Oil Corporation in

1984, the latter's $1 million annual contribution to its headquarters region of Pittsburgh was substantially reduced. On the other hand, a takeover need not reduce overall giving: the year after Chevron and Gulf merged, the enlarged giving program totaled $27 million, about what would have been expected of the two firms separately.[9]

When a corporate acquisition or merger significantly enlarges the takeover company, one byproduct may be an increase in the amount of funds available for culture and the arts. On average, smaller companies give a lower share of their contributions budgets to the arts than do larger firms. Of corporations with giving budgets under $500,000 in 1985, 9.1 percent of the total was allocated to the arts; of companies with giving budgets of $5 million or more, 11.2 percent was so allocated. Corporate concentration that follows an acquisition may thus not reduce the overall giving level, and it may even modestly increase the fraction allocated to the arts.[10]

The Impact of Leadership

Top management commitment is the second critical institutional factor. Senior managers tend to take an active interest in giving decisions, and the intensity of their support is found to have a decisive bearing on both the quality and scale of a giving program. A detailed study of 48 major companies with well-established giving programs reveals, for instance, that the chief executive's conscientious guidance made much of the difference in distinguishing well-run from less effective programs. "The components of excellence" in a contributions program, concludes the researcher, "can be most fully attained when they reflect the commitment and challenging support of the chief executive." Similarly, a study of 219 national corporations found that, other factors being equal, the percentage of pretax net income allocated to contributions by firms with highly committed chief executives was double that of firms whose CEOs' commitment was low.

Still another study, one of 672 corporations based in Massachusetts, reveals that companies whose chief executives were more vigorously involved in the contributions effort experienced higher growth rates in their budgets than did other firms. And, more specifically, enterprises with a chief executive who backed more spending on the arts were more than twice as likely as other companies to have enlarged the proportion of their gifts budget allocated to culture.[11]

The central role of the chief executive in corporate giving can make contributions programs exceptionally sensitive to shifting executive preferences. Although the rate of corporate giving had increased during the early- and mid-1980s, as gauged by the percentage of pretax net company income

allocated to contributions, the coming generation of senior company managers might look less favorably upon the giving function. Intensification of corporate mergers and workforce down-sizing during the past decade may be bringing to the fore a new generation of executives who are more cost conscious and less civic minded.

PREFERENCES IN CORPORATE SUPPORT FOR THE ARTS

Companies vary in the extent to which they are prepared to support the nonprofit world generally and the arts community specifically, but cultural organizations and programs also vary in the extent to which they are appealing to corporate funders. The major differences are evident in the survey that the American Council for the Arts conducted on the giving programs of major corporations in 1986 and in earlier surveys of giving programs in 1982 and 1979.[12]

Nearly all companies offer support to museums and other established arts organizations, while less than half backed arts activities practiced outside of major organizations or by individual artists themselves. Thus, of the nearly 500 companies responding to the ACA survey for 1986, 91 percent reported that they supported or were prepared to support museums, and 87 percent supported symphonic and chamber orchestras. By contrast, only 46 percent of the firms were supporting or ready to support literature, and 43 percent supported national arts organization (Table 3). Backing for individual artists was even less: 25 percent of the firms expressed support for all types of arts, presumably including individual artists, but only 3 percent explicitly reported backing individuals (not shown in Table 3).

The breadth of support for arts organizations and activities carries into the proportion of the arts budget that is allocated to each area within the arts. Conference Board surveys of 415 large companies in 1984 and 370 large companies in 1986 reveal that the leading dollar beneficiary is the museum field, which received nearly 20 percent of the total arts dollar (Table 4). Music followed with more than 12 percent, and public TV and radio with nearly 11 percent in 1986. Although such areas as dance are supported by more than three-quarters of the companies appearing in the ACA survey, dance garnered only 3 percent of the dollar support offered to the arts, implying that company gifts to dance are comparatively large in number but small in magnitude.

In evaluating an application for arts support, corporate donors place a premium on the proposed program's impact on the local community. When

TABLE 3: Percentage of Companies Supporting Arts Organizations and Activities, 1982-86

Arts Organization or Activity	1982	1986	Change 1982-86
Museums	91.8%	91.2%	
Symphony/chamber orchestra	74.9	87.4	12.5%
Public TV/radio	76.6	86.2	9.6
Theater	68.1	84.3	16.2
Opera	69.3	79.9	10.6
Community arts groups	87.3	79.0	(8.3)
Arts centers	64.1	78.2	14.1
Dance	61.7	77.6	15.9
Arts councils/united arts funds	72.2	72.1	
Visual arts/crafts	58.1	65.4	7.3
Film/video	36.5	49.3	13.2
Literature	32.6	45.7	13.1
National organizations	42.8	43.4	
Number of Companies	668	477	

Note: The percentages for symphony/chamber orchestra, opera, theater and dance do not include 25 companies in 1986 and 124 companies in 1982 that reported support for "performing arts" but did not specify any performing arts areas. The percentages for all areas include companies that indicated they supported "all types" of arts organizations and activities.

Source: ACA's Guide to Corporate Giving in the Arts, Third and Fourth Editions.

TABLE 4: Percentage of Dollar Allocation Among Beneficiaries of Corporate Support for the Arts, 1984 and 1986

Beneficiaries	1984	1986
Museums	19.6%	19.1%
Music	12.7	12.0
Public TV/radio	12.1	10.9
Employee matching gifts	5.8	7.4
Theaters	6.0	7.0
Arts funds and councils	5.4	6.1
Cultural centers	9.5	5.9
Dance	2.3	2.7
Other*	25.0	28.9
Number of Companies	415	370

*Other and subcategories unspecified

Source: Conference Board, Annual Survey of Corporate Contributions, 1988 Edition, Advance Report (New York: Conference Board, 1988).

asked to rank 14 criteria in evaluating an arts request, more than nine in ten of the companies surveyed by ACA for 1986 rated local community impact in the highest two categories of a five-category rating scale that ranged from "most important" to "least important" (Table 5). The local impact criterion was closely followed in importance by geographic location (stressed by 92 percent) and management capability (80 percent). Artistic merit was rated highly by two-thirds (66 percent) of the companies, a sign that artistic quality is an important but not an overriding criterion in reviewing applications. Of least importance were such considerations as whether the application had received support from foundations and government agencies (emphasized by only 14 percent) or individuals (11 percent).

A comparison of the company ratings in 1986 with those rendered by earlier ACA surveys for 1982 and 1979 indicates that almost none of these criteria diminished in importance. Several significantly increased in importance. Local geographic impact is now viewed by contributions managers as more important ("impact on local community" and "geographic location" both gained 5 percentage points). This attitude reflects in part the intensifying effort by many companies to channel more of their giving dollars through local plants and operations as a means of giving these company

TABLE 5: Percentage of Companies Highly Rating Fourteen Criteria in the Evaluation of Arts Requests, 1979-1986

Evaluation Criteria	1979	1982	1986	Change 1979-86
Impact on local community	87.6%	89.2%	93.4%	5.8%
Geographic location	86.7	89.7	91.9	5.2
Management capability	67.5	75.8	80.1	12.6
Artistic merit	59.6	53.9	66.1	6.5
Employee involvement	54.9	55.0	58.8	
Quality of application	43.3	48.9	48.7	5.4
Board of directors	38.5	40.9	44.7	6.2
Size of audience	34.1	40.0	41.3	7.2
Coordination with similar groups	23.4	26.0	28.2	
Support by other firms	27.5	26.0	26.2	
Publicity value	14.9	19.3	21.0	6.1
Matching grants	12.4	15.7	14.0	
Support by foundations/government	15.6	15.5	13.6	
Gifts from individuals	8.1	10.0	11.2	
Number of Companies	483	657	458	

Note: The ratings were on a five-point scale ranging from "most important" to "least important."

Source: ACA's Guide to Corporate Giving in the Arts, Second, Third and Fourth Editions.

locations greater visibility in their communities. Because approximately four out of five giving dollars are concentrated near headquarters, the trend may lead to greater geographic dispersion of the contributions budget.

The most marked change, however, is the heightened emphasis on the organizational capabilities of the applicant organization. Management capability is viewed as important by 80 percent of the firms surveyed in 1986, up 12 points from those contacted in 1979. Similarly, the quality of an arts organization's board of directors and the quality of the application itself are seen as more important as well. Arts fund seekers will thus need to manage more effectively both their own organizations and the way that they are presented to fund givers if the increasingly stringent criteria for funding in these areas are to be met.

Corporate donors look not only at the quality of the applicant organizations, but also at the functional area for which support is requested. Requests for general operating expenses are honored by four-fifths of the corporations surveyed in 1986, and special projects and capital projects received backing by approximately three-quarters of the firms (Table 6). Endowment campaigns, by contrast, found backing from fewer than a quarter of the companies, and international cultural exchanges from less than one-tenth of the firms. Comparing the 1986 company proportions to those recorded for several of these areas in 1982, the breadth of support for general operating expenses is slightly down (by 5 percentage points), support for special projects is slightly up (by 4 points) and support for capital projects is largely unchanged (the 1982 figures are not displayed in Table 6). The major growth area was that of preference for employee matching gifts, up by 7 percent in four years.

Noncash giving increased substantially in the early 1980s, and companies are more often seeking ways of providing materials, services and technical assistance to arts organizations. Conference Board comparison of the giving of a matched set of 322 corporate donors in 1983 and 1984 revealed that noncash charitable donations had more then doubled in that twelve-month period. Whereas noncash contributions constituted 11 percent of total deductible giving by major companies in 1983, noncash giving reached 22 percent of the total in 1984. One year later it dropped slightly, however, to 20 percent of total contributions. The growth of noncash giving has not come at the expense of cash contributions, the evidence indicates, as cash giving has largely continued to follow its own supply curve.[13]

Nondeductible forms of corporate assistance also grew in the early 1980s, but they may have leveled out as well. Included here are the loan of company personnel to nonprofit organizations for technical assistance, the

TABLE 6: Percentage of Companies that will Consider Various Kinds of Arts Support, 1986

Kinds of Arts Support	Percentage
General operating expenses	82.1%
Special projects	79.3
Capital projects	70.7
Employee matching gifts	36.1
In-kind goods and services	31.4
Technical assistance by company personnel	21.6
Sponsorship through advertising/PR	21.6
Endowment campaigns	20.9
International cultural exchange	7.7
Number of Companies	468

Source: ACA's Guide to Corporate Giving in the Arts, Fourth Edition.

TABLE 7: Percentage of Companies Providing In-Kind Services and Technical Assistance, 1986

Services and Assistance	Percentage
In-Kind Services	
Donated materials	49.3%
Donated company products/services	42.0
Printing	40.3
Meeting space	32.3
Exhibition space	18.4
Performance space	7.6
Technical Assistance	
General management	20.5
Planning	19.1
Accounting/fiscal management	18.1
Marketing	15.3
Advertising	14.2
Design services	10.8
Legal	6.6
Number of Companies	288

Source: ACA Guide to Corporate Giving to the Arts, Fourth Edition.

lending of corporate facilities and the gift of printing and other company services. The 1983-84 comparison of a matched set of companies by the Conference Board revealed a near doubling in the dollar value of nondeductible giving. A similar comparison for 1984-85, however, showed a 17 percent drop in the estimated value.[14]

TABLE 8: Percentage of Companies Providing Arts Sponsorships Through Advertising and Public Relations, 1986

Type of Sponsorship	Percentage
Public TV and radio	39.9
Music concerts	39.5
Exhibitions	33.5
Dance	32.7
Plays	31.7
Festivals	28.8
Gala benefits	23.5
Memberships	19.9
Performance tours	14.6
Competitions	13.9
Number of Companies	281

Source: ACA's Guide to Corporate Giving in the Arts, Fourth Edition.

As a result of the spread of noncash giving in the early 1980s, arts organizations are now benefiting from an array of in-kind services and technical assistance from companies (some deductible, others not). The most important form is the gift of company materials and products, practiced in 1986 by nearly half of the companies (Table 7). General management assistance is rendered to arts organizations by a fifth of the companies, and a few even offer free performance space and legal assistance.

Nondeductible support for the arts in the area of advertising and public relations has also become particularly important. Two-fifths of the 1986 companies surveyed by ACA sponsored public TV and radio through advertising and public relations efforts, and two-fifths backed musicals in this way as well (Table 8). Approximately one-third of the companies also use their advertising and public relations budgets to support exhibitions, dances and plays.

THE INFLUENCE OF MARKET AND INSTITUTIONAL FACTORS

For arts organizations seeking additional corporate assistance, the joint influence of market and institutional factors would suggest that they approach firms whose income stream has been rising and whose management has backed, or could be encouraged to back, giving to the arts. Growth in earnings usually translates into expanded giving. A newly developed or intensified commitment by a firm's top officers can do the same.

The mix of market and institutional factors also suggests distinctive ways

of approaching companies for support. For firms whose giving programs are more disciplined by market considerations, the potential payback of enhanced contributions should be made evident. It may be useful to point out, for example, the value of local contributions in improving a firm's reputation not only as a generous benefactor, but also as a well-run business.

FIGURE 1: Key Factors for Determining a Company's Funding Potential

MARKET FACTORS

1. The magnitude and trend of the company's earnings (publicly reported on a quarterly basis).

2. The percentage of earnings allocated to the contributions budget (identified for many major firms by major reference sources).

3. The percentage of the contributions budget allocated to the arts (also reported for many corporations by reference sources).

4. The company's product sector and the sector's relative rate of giving to the arts (reported annually by the Conference Board).

5. The corporation's interest in enhancing its reputation as a socially responsive and well-managed firm (informal discussions with community leaders may furnish relevant information).

INSTITUTIONAL FACTORS

1. The scale and professionalization of the company's contributions program (signified by a full-time staff and written application guidelines).

2. Commitment of the company's top management to the arts (manifest, for example, by the service of executives on governing boards of cultural organizations).

3. Involvement of company management in business and community affairs, a sign that the company may be responsive to the opinion and recommendations of other corporations and community leaders (such involvements are usually a matter of public record).

For other firms more driven by institutional factors, it may be equally important to couch an appeal in nonmarket terms. Particularly crucial here is the web of mutual influence and obligation among local corporate leadership. As noted, the top officers' active interest can decisively move a company to make a gift. It is known from other studies that CEOs and other senior managers look to one another for guidance in giving. Research indicates that "peer company comparisons" are an important factor in setting a contribution dollar level. Also, when a company is selecting a recipient for support, the influence of other firms is of critical significance, ranking in prominence with the intrinsic merits of the appeal.[15]

One of the most effective avenues for reaching previously untapped firms is for business trustees or other supporters of a cultural organization to approach senior corporate managers of other firms with whom they are familiar. And, if the approach is successful, that support in turn can encourage still other companies to be more forthcoming.

In identifying whether a company would be prepared to provide funding, an arts organization may find it useful to asses the factors listed in Figure 1. These factors do not constitute an exhaustive list, and compiling the necessary information can be time-consuming. Yet they are among the most important factors, factors critical to identifying which companies are most likely to be — or to become — generous benefactors of the arts.

The general prospects for fundraising in the arts depend upon the continued overall expansion of corporate giving. The rate of growth in the aggregate amount of business giving eased somewhat during the mid-1980s, and much of this could be traced to a slowdown in the rise of corporate income. Company commitment to the contributions function, as gauged by the percentage of pretax net income allocated to the giving budget, did not waver through 1986, though it may have lessened somewhat since then. Corporate support for the arts, as measured by the proportion of the contributions budget targeted for the arts, remained strong. As company income resumes its upward climb, so too should the level of corporate giving. Still, company commitments are never certain, particularly in an era of widespread corporate acquisitions and restructuring. The degree of certainty will partly depend on the effectiveness of the funding appeal by the nonprofit community to the corporate world.

NOTES

1. Michael Useem, "The Rise of the Political Manager," *Sloan Management Review* 27 (Fall 1985): 15-26; Michael Useem, *The Inner Circle:*

Large Corporations and the Rise of Business Political Activity in the U.S. and U.K. (New York: Oxford University Press).

2. Timothy S. Mescon and Donn J. Tilson, "Corporate Philanthropy: A Strategic Approach to the Bottom Line," *California Management Review* 29 (Winter 1987): 49-61.

3. Conference Board, *Annual Survey of Corporate Contributions, 1988 Edition,* Advance Report (New York: Conference Board, 1988)

4. Ferdinand K. Levy and Gloria M. Shapiro, "Social Responsibility in Large Electric Utility Firms: The Case of Philanthropy," *Research in Corporate Social Performance,* vol. 2, Lee E. Preston, ed. (Greenwich, Conn.: JAI Press, 1980); Ronald S. Burt, *Corporate Profits and Cooptation* (New York: Academic Press, 1983); Louis M. Fry, Gerald D. Keim and Roger E. Meiners, "Corporate Contributions: Altruistic or For-Profit?" *Academy of Management Journal* 25 (1982): 94-107.

5. Arthur H. White, "Corporate Philanthropy: Impact on Public Attitudes," in *Corporate Philanthropy in the Eighties* (Washington, D.C.: National Chamber Foundation, 1980); Richard E. Wokutch and Barbara A. Spencer, "Corporate Saints and Sinners: The Effects of Philanthropy and Illegal Activity on Organization Performance," *California Management Review* 29 (Winter 1987):62-77; Joseph Galaskiewicz, Social Organization of an Urban Grants Economy: A Study of Business Philanthropy and Nonprofit Organizations (New York: Academic Press, 1985), p. 214.

6. Mescon and Tilson, 1987.

7. Michael Useem, "Corporate Philanthropy," *The Nonprofit Sector: A Research Handbook,* Walter W. Powell, ed., (New Haven, Conn.: Yale University Press, 1987); Katherine Maddox McElroy and John J. Siegfried, "The Effect of Firm Size and Mergers on Corporate Philanthropy," *The Impact of the Modern Corporation,* Betty Bock, Harvey J. Goldschmid, Ira M. Millstein and F. M. Scherer, eds. (New York: Columbia University Press, 1984); Michael Useem and Stephen I. Kutner, "Corporate Contributions to Culture and the Arts: The Organization of Giving, and the Influence of the Chief Executive Officer and Other Firms on Company Contributions in Massachusetts," *Nonprofit Organizations in the Production and Distribution of Culture,* Paul DiMaggio, ed. (New York: Academic Press, 1986); Hayden W. Smith, *A Profile of Corporate Contributions* (New York: Financial Aid to Education, 1983).

8. Useem and Kutner, 1986.

9. McElroy and Siegfried, 1984, *op. cit.*; Paul Desruisseaux, "Mergers Held

Unlikely to Cause Overall Drop in Company Giving," *Chronicle of Higher Education,* March 19, 1986, pp. 21-22.

10. Conference Board, *Annual Survey of Corporate Contributions, 1987 Edition* (New York: Conference Board, 1987), p. 41.

11. E.B. Knauft, *Profiles of Effective Corporate Giving Programs* (Washington, D.C.: Independent Sector, 1985), p. 14; Arthur H. White and John Bartolomeo, "The Attitudes and Motivations of Chief Executive Officers," *Corporate Philanthropy: Philosophy, Management, Trends, Future, Background* (Washington, D.C.: Council on Foundations, 1982).

12. The surveys are largely of major corporations listed among *Fortune* magazine's top list of manufacturing and service sector firms, with a modest number of mid-sized firms (constituting from a fifth to a third of each survey's total number of companies).

13. Conference Board, 1987.

14. Conference Board, 1987.

15. Galaskiewicz, 1985; Useem and Kutner, 1986.

GOVERNMENT LEVERAGE OF PRIVATE SUPPORT: MATCHING GRANTS AND THE PROBLEM WITH "NEW" MONEY

by J. Mark Davidson Schuster

Government agencies that support the activities of nonprofit organizations are increasingly turning to matching grants to leverage increased private support. In an era of privatization and public/private partnerships — a trend both across nonprofit sectors and across a wide range of countries — the notion of combining public and private sources of support has considerable ideological appeal. In no other nonprofit sector in the United States has the matching grant become as popular as it has for the arts and culture. And this is just as true in other countries, which see themselves consciously turning toward the "American model" of arts support.

That the arts have been the first sector to experience the movement of government intervention toward matching grants is not terribly surprising. Charitable statistics indicate that the arts have demonstrated their appeal to private donors, particularly corporations. Matching grants try to exploit that appeal to increase the resources provided to the arts and culture.

If this assertion is true — that matching grants are becoming an increasingly popular mode of distributing government resources to the arts — it will become more and more important to understand the dynamics of matching grants. What are their financial implications? What are their aesthetic implications? When have they worked well? When have they worked poorly? What issues should be accounted for in their design?

Even though matching grants have been widely used for arts support in the United States, we have very limited information as to their effects. Arts funding agencies have not, for the most part, evaluated their matching grant programs with an analytical approach that would reveal their true effects. (Indeed, arts funding agencies have been reticent to evaluate any of their

funding programs.) In the discussion that follows, I integrate the limited research results with a more theoretical approach to consider the likely effects of matching grant programs.

THREE FORMS OF MATCHING GRANTS

In developing an analytic framework within which to consider matching grants, the first hurdle to overcome is the inadequate vocabulary we currently have to distinguish between various forms of matching grants. The single term "matching grant" has actually been used to characterize a family of related, yet distinct, modes of support. It is helpful to distinguish among three different forms of government matching grant support, all of which arguably belong under the umbrella of matching grants: co-financing, challenge grants, and reverse matching grants.[1] Each of these forms has its own characteristics and its own advantages and drawbacks.

Co-financing

From its beginning, the National Endowment for the Arts has followed the principle that it will not fund the total cost of any project; its enabling legislation specified that it could provide only up to 50 percent of the cost of any project it supported.[2] Thus, *co-financing* became the first, albeit implicit, matching grant; other funding sources were expected, if not formally required, to match or complement the federal grant. Politically, the co-financing principle was more widely acceptable than direct subsidy because of three fears: the fear that government control might come with the proposed federal involvement in the arts coupled with the belief that it could be minimized if there were a diversity of funding sources; the fear that public money would supplant private money that otherwise would have been given;[3] and the fear that government involvement in the arts would lead to almost unlimited financial demands unless its financial involvement were limited.[4]

Most state arts agencies have followed suit and have incorporated the co-financing principle into their funding programs. Even when government agencies have been willing to support higher proportions of project costs, the fact that the emphasis remains on *project support* rather than on *ongoing operating support* indicates that the net result is implicit co-financing.

It is this model of government matching support that the French Ministry of Culture and Communication seems to have had in mind when it announced its new approach to arts funding in the fall of 1986: *Le Cofinancement.* Projects in nine thematic areas that were previously eligible for sup-

port directly from the program areas of the Ministry would no longer have access to those old Ministry sources. Instead, they would have to make a proposal to the Ministry to enter into a co-financing agreement whereby private funds would be mixed with public funds. Within the Ministry, proposals would be approved first by one of four commissions (performing arts, heritage and books, visual arts and museums, and multidisciplinary arts) and then by a "Conseil Superieur du Mécéanat." A decision as to whether the government should enter into a partnership contract would be made and three parameters would be determined: the minimum amount of private funds the project had to attract to be eligible for government co-financing, the ratio of public money to private money at which co-financing would take place, and a ceiling on the amount of public money that would be committed to the project. The fixing of these parameters brings this program quite close to the other forms of matching grants, but the overall spirit of the program was to establish co-financing as a principle where it had not been established previously (even though it had been practiced). (The salient characteristics of the *Cofinancement* program, and of the other sample matching grant programs discussed here are summarized in Appendix A.)

The movement from what appeared to be direct government support to co-financing was not without its critics. The press interpreted this program as a broad policy change by the government whereby it would no longer be possible for arts organizations to receive government support without first being successful in attracting private support, a controversial suggestion in a country with a long tradition of substantial central government arts support.

Challenge Grants

More recently, the National Endowment for the Arts (NEA) has used explicit matching grants throughout its funding programs, most notably in the Challenge Grant program in which the recipient organization receives one dollar of its Challenge Grant for every three (or four) dollars it receives in "new" contributions from other sources.[5] For the Arts Endowment, the Challenge Grant had two seemingly contradictory advantages: it allowed it to leverage additional nongovernmental resources at a time when its budget growth had begun to slow, while it also allowed it to increase its budget in a new way, through a politically attractive program that stressed public/private partnership even more explicitly than co-financing had.

The Challenge Grant was designed to encourage arts institutions to think in terms longer than their yearly budgets by providing a multiyear matching grant to major cultural institutions for new and increased sources of continuing income.[6] Margaret Wyszomirski has argued that the Challenge

Grant initiative is an example of how the NEA has picked up program initiatives that have been designed, supported and pretested by the private sector, in this case by the major private foundations.[7] Whether or not this was the case, the Challenge Grant program is now seen as one of the Arts Endowment's most successful innovations.

The term *challenge grant* is a useful one to describe this type of matching grant because the government agency has to make an explicit decision to challenge a particular arts organization to increase its fundraising. Arguably, the challenge grant is the most familiar form of matching grant as well as that form most copied by state arts agencies and arts funding agencies in other countries.

Under the general title of "Incentive Funding," the Arts Council of Great Britain is currently in the process of launching two related challenge grant programs: the Enterprise Fund for well-established arts organizations of national or regional importance and the Progress Fund for small-scale, newly formed, innovative or community-oriented organizations.[8] Just as *Cofinancement* was a significant departure for the French Ministry of Culture, Incentive Funding represents a new era for the Arts Council in which greater emphasis is being placed on sources of revenue other than central government.

Reverse Matching Grants

The most recent matching grant programs, however, have taken on a new form, particularly when those matching grants have been targeted at increasing corporate support. These matching grants might be called *reverse matching grants* in that they promise that the government will match, more or less automatically, increases in private support of the arts. There is no government selection of the matching grant recipient beyond the broad determination of eligibility criteria. These grant programs reverse the logic of the traditional matching grant; they allow the private donor to make resource allocation decisions that are *followed,* rather than *led,* by the public sector's match.

The recent move to reverse matching grants has ideological roots in the turn toward private initiative as a trigger for appropriate public initiative, and it has a practical precedent in the deductibility of charitable contributions, which itself can be seen as a reverse matching grant. (Indeed, the new reverse matching grants augment the financial attractiveness of these tax-incentive-based matching grants because the donor's matching contribution is typically deductible.) If a government wishes as a matter of policy to mimic and augment private local decision making (as it would through an educa-

tion voucher program or through tax incentives), a reverse matching grant program in which the public match automatically follows the private decision is particularly attractive. It will also be attractive whenever there is an increase in the public sector's reticence to decide which artistic and cultural activities are worthy of support, decisions that involve unusually vague criteria of aesthetics and innovation and that touch on issues of censorship.

The National Endowment for the Arts has not yet used reverse matching grants, but they have been used at the state level—the Massachusetts Regional Corporate Challenge Program; at the provincial level in Canada— the Wintario Challenge Grant[9] and the Investment in the Arts programs in Ontario and the recently announced *Fond d'Appui* in Quebec; and internationally—the Business Sponsorship Incentive Scheme in Great Britain.

This tripartite division of matching grants is critical to an analytical understanding of their effects. The little research that has been done on the effects of matching grants for the arts has to be understood in the context of the form of matching grant that is being investigated. But in order to formulate an evaluative perspective, it is necessary to take a step backward to consider why matching grants are implemented in the first place. Once we understand the rationale(s) for matching grants, we will have a base from which to begin evaluating them.

WHY MATCHING GRANTS?

What is the theory behind matching grants? Why do governments choose to implement them? And why do they turn to matching grants rather than to unencumbered grant support as the chosen instrument of government policy?[10]

Unfortunately, governments have not been explicit about the reasoning that has led them to the use of matching grants to support the arts.[11] As a result, one is forced to infer theories from their actions, not always the most reliable guide. The theories that seem to underlie government matching grants fall into two general groups: (1) theories that focus on why the government should subsidize the arts at all, perhaps with some special emphasis suggesting the appropriateness of matching grants, and (2) theories that focus on why a matching grant ought to be chosen over other forms of government support.

Although it is beyond the scope of this paper to revisit the literature on the theoretical justification for government support of the arts,[12] at least two such lines of reasoning particularly have been used in connection with matching grants.

Moving Private Resources. If a government determines that a particular sector of the nonprofit economy is receiving too little support, as it would be if the marginal societal benefit of additional support of that sector is deemed to be greater than the marginal societal benefit in other sectors, it might design a program to move resources into the targeted sector. It might do so by directly supporting the targeted sector or by making the contribution of private resources to that sector more attractive by changing the relative prices of the various uses of those resources. To the donor, a credible matching grant can magnify the effect of his or her donation by the matching ratio, making that particular use of money relatively more attractive.[13]

Although this rationale is rarely made explicit, it is implicit in the rhetoric that surrounds much of the debate on new government arts support initiatives, particularly where increasing, large-scale, direct subsidy is no longer politically feasible. Understandably, though, the rhetoric mostly focuses on increasing private resources (from the perspective of the arts) rather than on moving them around.

Interjurisdictional Spillovers. Programs that are funded entirely on the local level may be underfunded if they involve positive externalities that are enjoyed by individuals who are not members of the local community. Such an argument has often been made with respect to the funding of arts institutions. In such cases it can be argued that there ought to be cost sharing with a higher level of government that collects its revenues from those taxpayers who are enjoying those externalities. A matching grant is one form that such cost sharing might take. This rationale, of course, is more applicable to projects that are begun on the local level and expanded by the match than to projects that are begun on a higher level and sold to local communities.

Use of this rationale implies that the matching ratio should be related to the actual distribution of benefits from the program. If benefits are national, it is appropriate for the central government to assume most, if not all, of the costs. If the benefits are highly localized, a relatively high proportion of the cost should be picked up by local government or by contributions or earned income from private sources.[14]

This rationale has been evident in the programs in the Endowment's Office for Public Partnership in which matching grants have been given for the creation and ongoing funding of state arts agencies and, more recently, for the creation and increased funding of local arts agencies.

Beyond the general arguments for government support lie several lines of reasoning that argue that matching grants should be chosen over other forms of government support.

Multiplication of Limited Resources. In an era in which public resources are believed to be limited, it becomes particularly important to multiply the effect of those resources to maximize the impact of a public policy, and a matching grant seems a logical mechanism to accomplish this end. A perceptible change in the relative price of the use of private resources may not only cause a movement of private resources from one sector to another, as mentioned above; it may also cause an overall increase in the amount of private resources dedicated to nonprofit activities. (The marginal benefit of each dollar invested is greater than one dollar in the presence of a matching grant; thus, the arts are a more attractive "investment" with the match rather than without it.)

A version of this argument is embodied in a concern that government grants "crowd out," and thereby substitute for, private grants rather than augmenting them if private donors decrease their donations in the presence of increased government support. Susan Rose-Ackerman has argued, for example, that if two programs with the same tax consequences are compared, a matching grant lowers giving less than a fixed-sum grant does and may actually produce increased giving.[15]

Despite their differences, the rhetoric surrounding the matching grant programs mentioned above suggests that they are all fundamentally directed at increasing the resources available to arts institutions. It is this goal that has led to the emphasis on matching "new" money in many matching grant programs, an emphasis that is discussed below. How effective is a matching grant at increasing resources for the arts beyond the government's portion of the match? (Or, in an economist's terms, what is the grant's "treasury efficiency?") Whether or not matching grants succeed at this goal is the central evaluative question.

Because of the specification of an explicit matching ratio, challenge grants and reverse matching grants are likely to be more effective in this regard than co-financing. Furthermore, challenge grants and reverse matching grants are likely to be more effective in increasing private contributions or contributions from lower levels of government, both situations in which the matching benefit is easier to communicate, than they will be in increasing earned income, where it is difficult to imagine how the promised match can be made a credible factor. (It may, of course, cause arts organizations to redouble their efforts at earning earned income, but in the first instance it will not provide an incentive for consumers to consume more).

Testing of Local Demand. Particularly in new areas of government intervention, a higher level of government may wish to test the degree of local commitment to a project as measured by its willingness to spend local

resources. In this way implementation may be better assured. Testing of local demand can be seen as a particularly proactive form of accounting for interjurisdictional spillovers. This rationale, too, has been very much in evidence in the programs in the Endowment's Office for Public Partnership.

To be sure, it is not only governments that initiate matching grants to test local demand. Private donors used matching grants in the arts for this reason before government agencies picked them up. For example, Andrew Carnegie, before providing communities with a Carnegie Foundation grant to build local libraries, insisted that they would have to raise from taxes an annual amount for maintenance equal to one-tenth of the grant.[16]

The most extreme form of testing local demand is load shedding. The combination of limits on public resources and the increasing shift toward privatization of previously public programs has led governments to shed programs entirely, with the assumption that if they were in sufficient demand they would be picked up by local government or by the nonprofit sector.[17] A matching grant might provide a transition by attracting the private resources to make load shedding supportable both politically and economically.

Among arts organizations much of the fear of matching grants, particularly in Europe, is that programs that are being advanced under other guises will actually turn out to be load shedding and that individual projects will be insupportable by other sources of funds.

Diversification of Sources of Support. It is often argued that one of the strengths of American support for the arts is that it involves a diversity of sources making a diversity of decisions concerning which art forms and which art activities are worthy of support. This argument is perhaps made more on aesthetic grounds (a wider variety of artistic experiences will be provided) than on financial grounds (more money will be available), but both undoubtedly play a role. To the extent that matching grants provide incentives to extragovernmental sources of support, they are seen as important contributors to that diversity.

This rationale is apparent in those matching grants where the uses of the government match or of the resources that are being matched are unrestricted. Some matching grant programs, particularly the examples of recent reverse matching grant programs cited above, are designed to increase and multiply the importance of *specific* sources of support, for example, corporate sponsorship, thus piggybacking other substantive programmatic goals on top of those discussed here.

In any particular matching grant program a combination of these motiva-

tions is at work, sometimes in internally contradictory ways. It is critical to understand which of these motivations is at work in order to evaluate a particular matching grant program in its own terms.

TOWARD AN EVALUATION OF MATCHING GRANTS

Unfortunately, very little research has been done on government matching grants for the arts. This section of the paper combines a practical discussion of the issues suggested by the existing research with a more theoretical discussion of the potential pitfalls. Because my research has focused on reverse matching grants,[18] much of what can be reported may be uniquely applicable to that form of matching grant, but the points at which those results can be generally applied to other forms are indicated.

Each of the theories of matching grants implies different goals for the match. Each of these goals is taken as a point of departure, asking what is known about how successful matching grants have been and can be at achieving that goal.

The Problem with "New" Money

The most frequently cited role for matching grants is the multiplication of limited resources, and most matching grants in the arts have been designed to accomplish that goal by attracting "new" money to the arts. But it has been particularly difficult to achieve a consensus as to what the concept of "new" money means in operational terms. In most cases, new money has been taken to include both first-time contributions and increased annual contributions, perhaps with a different matching ratio for each (the Ontario Investment in the Arts program and the British Business Sponsorship Incentive Scheme); in some cases the definition of new money has included increased earned income (Advancement Grants under the NEA Challenge Grant program), and in at least one case an attempt has been made to control the balance of new money between contributed income and earned income (the Arts Council of Great Britain's Incentive Funding scheme). Only in the French *Cofinancement* program has the concept of new money not been important as a matching requirement — as is appropriate in a co-financing program.

Although each of these programs has attempted to operationalize the concept of new money, arts funding agencies have discovered that within any definition of new money there is still considerable leeway, leeway that may compromise the program's ability to attract money that is truly new.

(For four examples of how one might design a grant to match new money, see the box below.)

It is instructive to begin to look at the issue of new money through the lens of the Massachusetts Regional Corporate Challenge Program, the matching grant program that began with perhaps the most ambitious and restrictive definition of new and increased money. This program was originally designed to match net increases in the aggregate of corporate cash contributions for general operating support by the members of a Regional Business Committee in each region of the state. In other words, a match

How to Design a Matching Grant

To illustrate the different methods in which a matching grant might be designed to match "new" money, imagine a state in which there are three donors (Donors A, B and C) and three arts institutions (Institutions 1, 2 and 3). The change in donor contributions in one year might be as follows:

Donor A increases its total annual contributions to the arts by $500 and gives the increase to Institution 1.

Donor B decreases its annual contribution to Institution 2 by $300 and gives that $300 to Institution 3 instead. Donor B also adds an additional, new donation of $100 to its contribution to Institution 3. Thus, its total contributions to the arts increase by $100 net.

Donor C decreases its total annual contributions to the arts by $200 by decreasing its contribution to Institution 3 by that amount. Thus, Institution 3 realizes a net increase of $200 in its contributed income (+ $400 from Donor B and - $200 from Donor C).

Donor A:	+$500	(to Institution 1) ⟶	Institution 1:+ $500	(from Donor A)
Donor B:	−$300	(to Institution 2) ┌⟶	Institution 2:−$300	(from Donor B)
	+$400	(to Institution 3)		
Net	+$100			
			Institution 3: +$400	(from Donor B)
Donor C:	−$200	(to Institution 3) ⟶	−$200	(from Donor C)
		Net	+$200	

There are four ways in which "new" money might be matched. Several of them pose tricky problems as to which arts institution should ultimately receive the match.

would be paid only if total corporate contributions to all organizations in the region went up.

Once the program was implemented, however, the Massachusetts Council on the Arts and Humanities quickly found itself under pressure to move off this high ground. Some of the Regional Business Committees lobbied successfully to have the Council match net increases by single members of the Regional Business Committee so that businesses whose corporate support dropped would not be counted against those whose aggregate had increased. Then, arts organizations began to lobby the Council, first to match net increases in aggregate corporate contributions made to each organiza-

Method #1: Match the net increase in the aggregate of donor giving.

In this example total donor giving went up by $400 = $500 + $100 - $200. But it is not at all obvious which institutions would receive the match. It might be prorated in proportion to the increases received by those institutions that actually received an increase or by some other method.

Method #2: Match the net increase of each donor.

In this case the total match would be $600 = $500 + $100. It seems clear that Institution 1 would receive $500, but should Institution 3 receive only $100?

Method #3: Match the net increase in donations received by each institution.

In this case the match would be $500 for Institution 1 and $200 for Institution 2, a total match of $700. There is no ambiguity in the distribution of the match.

Method #4: Match increases in each case where a donor made a net increase in its total donation to a specific arts institution.

In this case the match would be $500 for Institution 1 and $400 for Institution 3 (because of the increased contribution of Donor B), a total match of $900. There is no ambiguity in the distribution of the match.

Both donors and arts institutions have an interest in moving the match away from Method #1 toward Method #4, increasing the cost of the match every step along the way.

tion (so it would not be penalized by decreases to other organizations) and finally to match any increase from any of its corporate donors. Thus, the original criteria were successively relaxed, each time making the matching program more expensive for the state and less effective in promoting the original goal of increasing aggregate corporate giving. By its third year, the Regional Challenge Program found itself even increasing the aggregate matching grant to regions where corporate support had declined.[19]

The concept of new money was relative. To the state, "new" money was an increase in the annual aggregate of corporate giving. To each arts organization, "new" money was the increase in support that it received from each corporate donor. And, for obvious reasons, the arts organizations did not want to have to net out the decreases from those donors who had decreased their contributions. From the perspective of each corporate donor, "new" money was seen, at the very least, as the increase in the corporation's total charitable budget for the arts. But it is not too difficult to argue cogently that, for any private donor in a new year, *any* contribution is new money in that it represents a new decision and a new expenditure.

The more restrictive the definition of new money, the more likely it is that a matching grant will actually multiply limited resources (and the less likely it will actually be used). But whatever definition of new money is used, it is critical that the government agency providing the match (or its designated agent) be able to document clearly that the definition of new money has been met. This stipulation requires an agency that is willing to take a firm hand with its clients and insist on rigorous paperwork and documentation. The Ontario Ministry believes it has been able to assure that only new money has been matched because of its requirement for audited multiyear financial statements and its insistence that the matching grant and the matched private funds be accounted for in specified ways. These guidelines not only reinforce the definition of new money but also are intended to force the organization to spend both flows of the money according to the requirements of the program. In Great Britain, the Association for Business Sponsorship of the Arts insists on documentation from both partners in the Business Sponsorship Incentive Scheme – the arts organization and the corporate sponsor – because both perspectives must be checked to be certain that its definition of new money has been met.

But both of these cases are examples of places where government arts agencies have a long tradition of investigating the fully audited accounts of their clients because the government is a major provider of direct ongoing operating support to the institution. Where the arts funding tradition has been one of funding projects, as it has been for the most part in the United

States, the government agency seems less able to insist on standardized audited accounts. Even so, the more money at stake (as in the NEA Challenge Grants) the more willing the agency may be to require costly and time-consuming documentation. A major difficulty in the Massachusetts program was the lack of standardized documentation procedures across regions and across institutions. At any point in the program it was very difficult to check what definition of new money was being used and whether the flows of money that were being matched actually met that definition.

What seems clear from this evidence is that arts organizations and private donors can be expected to act together to move any program to match new private money toward a program that matches increases by individual donors to specific arts organizations, the most desirable outcome from the standpoint of the donor, the most remunerative outcome for the arts organization (in the short run) and the most costly and perhaps least effective outcome from the perspective of the government funding agency.

How Effective Are Matching Grants?

To what extent have increased private resources been induced by matching grants? Any government agency would like to be able to say — and many do — not only that its matching grant elicited the private match its matching ratio would imply but also that it had gone well beyond that ratio. For the most part, however, arts agencies have not yet done the research that would help them ascertain how effective the programs have been.

Invariably, once matching money has been spent, government arts agencies report that their matching grants have been a success and that private donations (or whatever is intended to be matched) must have increased in proportion to the matching ratio. Although the data collected within most matching grant programs are insufficient to document the true extent of matching, the experience with several matching programs, particularly the Massachusetts one, suggests that extrapolating from the matching ratio may be overly optimistic. And the effective matching ratios that are publicized in annual reports may be subject to creative accounting themselves. The National Endowment's Challenge Grant program uses a particularly creative procedure to calculate its effective match: it adds all the private donations made during the four-year life of the grant irrespective of whether they are "new" or "old" and irrespective of whether they continue to grow.[20] With this approach it is not surprising that the NEA reports effective matching ratios of 8:1 or higher.

Beyond the fact that successive relaxation of the program criteria led to increasingly expensive matching grants, the evaluation of the Massachusetts

Regional Corporate Challenge Program also documented that private donors, with the cooperation, if not the urging, of the recipient arts organizations, gradually adopted a wide range of entrepreneurial responses to the matching grant, maximizing the match while minimizing the cost to corporate contributors and thereby reducing its effectiveness.[21] Those entrepreneurial responses that may be generalizable to other challenge grant and reverse matching grant programs include the following:

Redirection Among Institutions. Moving a constant contribution around to different eligible arts organizations each year makes the contribution appear to be new money from the perspective of each new organization. A match can also be triggered by moving a contribution from an ineligible institution to an eligible institution.

Moving Donations Over Time. A match can be triggered by moving donations forward or backward over time and aggregating them: for example, a bank that normally gives $500 on an annual basis might be asked to make one contribution of $1,500 to cover the next three years, triggering a $1,000 match without increasing aggregate contributions over time.

A match could also be triggered through cyclical donations. If the donor were to make contributions every other year instead of every year, each contribution would be matched in full because it would look like a new contribution when compared with data from the previous year.

It is to avoid these problems that the Ontario programs use an unusual method for determining whether a contribution is matchable. First, an average fundraising base — the average percentage of operating income raised through private fundraising — is determined for each organization averaged over several years preceding the organization's participation in the program. Only increases in private fundraising above the amount of fundraising implied by multiplying the base percentage by each year's operating income are matchable.

Redirection Among Corporate Affiliates. Corporations with a variety of allied entities could move their contributions around internally each year, making them look as though they were coming from new corporate donors and triggering a match. In Ontario, the private foundations directly affiliated with the major arts organizations, hoping to trigger matches, moved money into the budgets of their affiliated organizations even though the money was, in a real sense, already available to be used for the programs of that arts organization.

Substitution for Private Contributions. Perceiving that its support can be provided to the arts at half price (with a 1:1 match), the donor may ac-

tually end up giving less than he or she might otherwise have given. This response to a matching grant means that private money has substituted for public money rather than supplementing it (an example of the "crowding out" phenomenon mentioned earlier). In all three reverse matching grant programs, interviewees said that their fundraisers loved the matching grant because it meant that they had to raise only half of the cost.

Yet, at the same time the contradictory "load shedding" view is also evident in the field. This view contends that the overall result of a matching grant may be the eventual substitution of private resources for public resources and a weakening of the public sector's commitment to the arts. This point of view sees the half-price deal as a deal enjoyed by the government; it is able to buy programmatic initiatives at half-price.

In some cases, governments themselves have been entrepreneurial with matching grants. In the NEA Locals Test Program, another challenge grant, one local government pledged rent-free office space as part of the match of federal monies. When the matching grant was awarded, the local government turned around and began charging the local arts agency rent, recouping the federal match to its own advantage.

All of these responses have been observed in one or more of the three reverse matching grant programs. In certain regions of Massachusetts the bulk of the match received can be attributed to these entrepreneurial responses rather than to real increases in private support. Program administrators in Ontario and Great Britain, while recognizing that some such responses have occurred, believe that they have kept them to a minimum. Undoubtedly these responses exist in challenge grant programs as well.

To be sure, the extent to which each response dilutes the overall leveraging effect of each program is a function of the care that was taken in program design and reporting requirements. Without a firm fulcrum a lever cannot work.

From a public policy standpoint it would be desirable to be able to predict in which circumstances these, and other, unforeseen entrepreneurial responses are likely to occur. One possibility is that private giving has different levels of maturity in different countries or in different regions. If there is little precedent for private giving, it will be difficult to begin, but a matching grant may be the appropriate lever. If, on the other hand, private giving is already at a relatively high level, a matching grant may be more successful in fueling entrepreneurial responses than in encouraging true increases in giving.

These entrepreneurial responses are quite concrete and are relatively

easy to document if one is so inclined. But there is a more fundamental question that is much more difficult to address. Attracting increased private resources to the arts must have implications elsewhere, perhaps in fewer resources available to other nonprofit activities, perhaps in lower net corporate profit, or even perhaps in lower contributions to one arts organization, offsetting higher contributions to another. The fullest accounting for matching grants would take these foregone opportunities into account in evaluating the overall effect of matching grants as a policy instrument.

While considerable research has been done on the efficiency of tax incentives in encouraging private contributions,[22] the extension of that work to matching grants has not yet been made.

Other Goals for Matching Grants

What is currently known about the ability of matching grants to meet goals other than multiplication of resources? Even less than is known about their economic efficiency, but a few observations are possible.

With respect to the testing of local demand, experience suggests that arts agencies may ultimately be unwilling to carry through on a matching grant as a full test of local demand. For example, Netzer has criticized the NEA's support for state arts agencies on these grounds.[23] The Federal/State Partnership Program was intended to provide an incentive for the creation of state arts agencies through federal matching grants to each of the states. Through the 1970s many states failed to fulfill their matching requirements; yet the full NEA match was allocated annually to each state, despite the fact that the test of local demand was not met.

In one of its early drafts, the Enterprise Fund in the Arts Council of Great Britain's Incentive Funding program included a test of local demand. Even though it was a multiyear program, the Arts Council suggested that it would be willing to pay a large proportion of the estimated Enterprise Grant in advance with the stipulation that it would be returnable to the government if the arts organization failed to meet its three-year target for fundraising. This stipulation was sufficiently controversial that the returnability clause was eventually dropped from the program regulations; in a sense, the Arts Council came to the conclusion that politically it would not be willing to enforce a test of local demand.

The increasing popularity of matching grants has led to the complaint that testing local demand is unduly problematic because of matching grant congestion. Multiple matching grants made to one geographical area by agencies at various levels of government as well as by private individual,

corporate or foundation donors have led to "saturation," prompting vigorous competition among groups for limited local philanthropic resources.[24] From the standpoint of a single government arts agency this competition should not be too troubling if its goal is the testing of local demand. All arts institutions that meet the general criteria of the matching grant program are given the opportunity to play on a "level ball field" and local demand expresses its preferences among them. From this perspective, reverse matching grants are the preferred form of matching grant. Challenge grants complicate the equation considerably, particularly if they are being made available to a small number of selected institutions who are being targeted for other policy reasons. Matching grants from other donors can also affect the slope of the terrain in a way that is outside the control of the single arts agency attempting to test local demand.

The use of matching grants to diversify the sources of support for the arts can also be problematic. Even if matching grants can lead to short-term gains in this area, which they seem to have done, no one has yet figured out how to study if those changes are sustainable. But an even more fundamental dilemma concerning diversity is inherent in matching grants.

In the very quest for diversity through matching grants lies the germ of its demise: a matching grant is designed to make funding sources fall in line with, and parallel, one another. Thus, decisions concerning arts support become dependent rather than independent. This warning is particularly salient for the challenge grant form of matching grants. The National Endowment for the Arts has often been very clear that part of its role is to provide a "seal of approval" through its funding decisions, signaling to other sources of income that the recipient organization is worthy of their support as well. The other side of this coin is that private funding sources, particularly corporations, have been criticized for their unwillingness to exert independent aesthetic judgments and for their over-reliance on the endorsement of the government to trigger private actions.[25] This is not a criticism of diversity as a goal; rather, it is an observation that a matching grant might not work quite as it was expected to work with respect to increasing diversity.

These issues do not exhaust the list of questions one might wish to ask of matching grants, but they do comprise the first level of research interests. The glowing press releases issued by arts funding agencies concerning their matching grant programs do not tell the whole story; there is ample opportunity to improve and refine those programs with the aid of focused research.

THE FUTURE OF MATCHING GRANTS

Politically, matching grants have become very popular. More and more matching grant programs are being launched both in the United States and abroad. What form might we expect matching grants to take in the future?

Framing the question of matching grants as a question primarily concerned with the relationship between arts organizations and their sources of revenue misses a critical point about the recent political popularity of matching grants. Recent matching grants may, in fact, have more to do with the relationship between the government arts agency and *its* funding source than with the relationship between the arts organization and *its* funding source.

Matching grants have not been the centerpiece of any government's funding strategy vis-à-vis the arts. Rather, they typically represent marginal increases in a government's funding commitment, even in the United States where the overall level of government support for arts organizations is so much lower as a percentage of operating expenditures than it is in other countries. And therein lies a key to understanding the new popularity of matching grants in the arts.

In a period in which government resources have been perceived as limited, those government arts-funding agencies that have proposed matching grants to their legislatures seem to have had greater success in convincing the legislatures to increase their budgetary commitment to the arts. The Regional Corporate Challenge Program was designed in response to the Massachusetts Legislature's suggestion that it would increase the Council's budget only if the increment were to be used to leverage further private support. The Wintario Challenge Grant and its successor, Investment in the Arts, were designed to get the Ministry access to otherwise unavailable provincial lottery monies. The Business Sponsorship Incentive Scheme was the only way that then Minister, Lord Gowrie, claimed he could get additional resources for the arts, and even then those resources were administered through a private nonprofit agency, the Association for Business Sponsorship of the Arts, because of the government's policy that no new program that could be administered in the private sector would be allowed to be administered in the public sector. The Incentive Funding program was a response by the Arts Council of Great Britain to the next Minister, Richard Luce, who strongly hinted that such a program would provide the only opportunity for him to increase the Arts Council's grant. And Challenge Grants were a means whereby Nancy Hanks could ensure continued growth in the NEA's budget.[26]

The only exception seems to be the French *Cofinancement* program, in which a portion of the Ministry's budget was separated out and used in a different way. The major criticism of that particular program is that it has been simply a repackaging of business as usual by which the same projects are funded at the same level as before with the same mix of public and private resources.

Seen from this perspective, the important leverage provided by matching grants lies less in the degree to which it leverages new *private* support than in its ability to leverage new *government* support for the arts.

Another trend deserves particular attention. Many recent matching grant programs have been part of a focused effort to increase corporate support. Countries in which private support has historically been small seem to believe that they should seek private support in those places where it is easiest to make the case that the arts can provide an identifiable benefit to the donor, and this approach suggests an emphasis on corporate donors who can use the arts to enhance their public image. Even in places with substantial private support, growth in corporate support is being emphasized, but it remains to be seen just how much corporate support can actually be increased in various countries. Undoubtedly, the upper limit will vary considerably depending on historical and cultural factors.

Significantly, it is the reverse matching grant, the most recent form of matching grant to appear, that has been focused on corporate support. Two reverse matching grant programs are targeted specifically toward corporate support, and the second phase of the Ontario program rewards corporate support through a higher matching ratio. Is the fact that all three programs also provide reverse matching coincidental? Or can it be linked to the pursuit of corporate support?

To sell a support program on the grounds of benefit to the corporate donor virtually requires that the corporate donor's logic be allowed to lead the program. Where does that donor see the clearest and highest benefit? A reverse match, if it results in increased giving, furthers the donor's choice; unlike a challenge grant, it does not attempt to shape the donor's choice (beyond moving it into the arts sector). Moreover, it can be seen as providing a government endorsement of sorts for the corporation's activity. One might even suggest that these reverse matching grants emphasize the establishment of direct identifiable benefits to the donor more than the financial benefit to the donee. The Ontario program, for example, was restructured when its administrators realized that corporate donors were not interested in providing endowment support and would prefer that their support go to ongoing operations where it could be associated with identifiable projects

(even though projects were not supposed to be matched). Similarly, in Massachusetts considerable pressure was exerted to get corporately funded projects matched.

This logic has been taken to the extreme in the Business Sponsorship Incentive Scheme. Not only is the program limited to matching increased sponsorship, which in British tax law must be demonstrably in the direct interest of the corporate sponsor (as compared to philanthropy), but the public match is to be spent by the arts organization to "enhance" the value of the sponsorship to the corporate sponsor. Some sponsors have taken this one step further by making those "enhancement" expenditures themselves and then recouping the match from the arts organization when it is received, totally internalizing the benefit to themselves.

Some research has been done on the effect of piggybacking public support on private decisions, though it has focused primarily on the effect of the matching grants implicit in tax incentives.[27] Research has also been done on the patterns of charitable support for the arts, and what clearly emerges is that corporate donors have their own preferences that are not necessarily in accord with articulated public policy vis-à-vis the arts.[28] The effect of these preferences is magnified by reverse matching.

If your view is that government policy vis-à-vis the arts should be proactive, pursuing goals that are not necessarily reflected in the marketplace of private arts funding, you should prefer challenge grants as a policy instrument and find the recent trend toward reverse matching grants troublesome. But if your view is that government policy vis-à-vis the arts should be reactive, picking up clues about funding priorities from that marketplace of private arts funding, you should find reverse matching grants to be the preferred alternative. Perhaps it is co-financing that ultimately strikes a balance between the two.

In any event, it is clear that the issues related to matching grants are more complex than arts funding agencies seem to have been willing to admit. As matching grants become more widely adopted, these will become increasingly important.

NOTES

1. In this discussion I have chosen not to treat the anomalous Treasury Fund Grant as a fourth form of matching grant as it is designed, in the first instance, more to attract private funding *to* the Endowment. Each year Congress appropriates Treasury Funds as part of the Endowment's budget. These funds can be spent only if a private donor makes a con-

tribution to the Endowment, thus freeing up the same amount of Treasury Funds. This total is then granted to an arts organization according to the Endowment's normal grantmaking procedures. The recipient organization is required to find additional private donations to match the total grant received from the Endowment on a one-to-one basis. The net result is a 3:1 match of Endowment Treasury Fund money. This arrangement combines characteristics of the three pure forms of matching grants discussed in the paper.

2. National Foundation on the Arts and the Humanities Act of 1965, Public Law 209 — 89th Congress.

3. The large private foundations had begun using matching grants when they became involved in arts funding for exactly this reason. They were particularly concerned about avoiding substitution of funding sources because their primary focus was on *improving* the financial health of arts institutions. William J. Baumol and William G. Bowen, *Performing Arts: The Economic Dilemma* (Cambridge, Mass.: M.I.T. Press, 1967), p. 344.

4. For a discussion of these fears see Fannie Taylor and Anthony L. Barresi, *The Arts at a New Frontier: The National Endowment for the Arts* (New York: Plenum Press, 1984), pp. 21-54.

5. Diane J. Gingold, *The Challenge Grant Experience* (Washington, D.C.: National Endowment for the Arts, 1980).

6. Taylor and Barresi, *The Arts at a New Frontier,* p. 172.

7. Margaret Jane Wyszomirski, "The Politics of Art: Nancy Hanks and the National Endowment for the Arts," in *Leadership and Innovation: A Biographical Perspective on Entrepreneurs in Government,* Jameson W. Doig and Erwin C. Hargrove, eds. (Baltimore: The Johns Hopkins University Press, 1987), pp. 231-32.

8. Arts Council of Great Britain, "Better Business for the Arts: An Introduction to the Arts Council Incentive Funding Scheme for Arts Organisations," Brochure, 1988.

9. In the sense in which I have used this term the Wintario Challenge Grant is not a challenge grant. It is a reverse matching grant.

10. These rationales are partially discussed in the literature on fiscal federalism. See, for example, Edward M. Gramlich, "Intergovernmental Grants: A Review of the Empirical Literature," in *The Political Economy of Fiscal Federalism,* Wallace E. Oates, ed. (Lexington, Mass.: Lexington Books, 1977).

11. Harold Horowitz, former Director of Research for the National Endowment for the Arts, has recounted his amazement at leaving the National

Science Foundation, where each time a matching grant was proposed for a particular initiative an intellectual debate took place testing its appropriateness in that instance, for the Endowment where matching grants had clearly entered into the agency's operational mythology and, as a result, were unquestioned.

12. Good summaries of this literature are contained in Dick Netzer, *The Subsidized Muse: Public Support for the Arts in the United States* (Cambridge, England: Cambridge University Press, 1978), chap. 2; Mark Blaug, ed.*The Economics of the Arts* (Boulder, Col.: Westview Press, 1976); C.D. Throsby and G.A. Withers, *The Economics of the Performing Arts* (New York: St. Martin's Press, 1979), chaps. 10 and 11; Baumol and Bowen, *Performing Arts: The Economic Dilemma,* chap. XVI; and John W. O'Hagan and Christopher T. Duffy, *The Performing Arts and the Public Purse: An Economic Analysis* (Dublin, Ireland: The Arts Council, 1987), chap. 1.

13. The word "credible" is important here. Because matching grants have become so popular, many organizations are even suggesting to their donors that they make their donations contingent on the receipt of donations from others. Arts organizations I interviewed pointed out that they create phony matches all the time, hoping to attract more donors. Saturation is bound to come with the overuse of this strategy.

14. Dick Netzer, *The Subsidized Muse,* p. 192.

15. She goes on to argue that in certain instances fixed-sum grants may increase giving too, but that line of reasoning is less important for the current argument. Susan Rose-Ackerman, "Do Government Grants to Charity Reduce Private Donations?" in *Nonprofit Firms in a Three Sector Economy,* COUPE Papers on Public Economics #6, Michelle J. White, ed. (Washington, D.C.: The Urban Institute Press, October 1981), pp. 95-114. For a discussion of crowd-out of local government support by federal support that has relevance to this point see Richard Steinberg, "Donations, Local Government Spending, and the 'New Federalism,'" in *Looking Forward to the Year 2000: Public Policy and Philanthropy,* Working Papers from the 1988 Spring Research Forum, Independent Sector, Washington, D.C., pp. 376-91.

16. Harold Kalman, "Canada's Main Streets," in *Reviving Main Street,* Deryck Holdsworth, ed. (Toronto: University of Toronto Press, 1985), p. 15.

17. For a useful discussion of load shedding in the context of a discussion of the wide range of relationships between nonprofit institutions and the government see Christopher Hood, "The Hidden Public Sector: The

World of Para-Government Organizations," Studies in Public Policy #133, Centre for the Study of Public Policy, University of Strathclyde, Glasgow, Scotland, 1984.

18. I know the Massachusetts reverse matching grant program best because I was commissioned to evaluate the program for the state arts council: J. Mark Davidson Schuster with Nancy Perkins, *The Regional Corporate Challenge Program: An Evaluation for the Massachusetts Council on the Arts and Humanities,* unpublished report, 1986. For the other two programs I conducted a number of interviews with program administrators, donors and arts organizations, but the level of detail was, of necessity, limited, so many of the issues that I was able to document in the Massachusetts program may also be present in the others but were able to avoid my coarser net of inquiry.

19. Schuster and Perkins, *The Regional Corporate Challenge Program.*

20. A simple example makes this clear: Take an arts institution with one private donor, a corporation that gave $10,000 in the year prior to the institution's entering into the Challenge Grant program. The Challenge Grant program offers to match increases over that base gift over four years. Suppose in the first year of the Challenge Grant the corporation gives $22,000, an increase of $12,000 over the base. That increase attracts a Challenge Grant of $4,000 at the 3:1 matching ratio. In the remaining three years the corporation goes back to its previous level of giving and gives $10,000 in each year, freeing up no further Challenge Grant money. At first glance, it seems logical that one might argue that the $4,000 match attracted an increase of $12,000, but if one averages the increase out over the life of the grant, one might also argue that the $4,000 match leveraged an (average) increase in private support of $3,000 ($12,000/4). The Endowment, however, reports that the $4,000 match leveraged a total of $22,000 + $10,000 + $10,000 + $10,000 = $52,000, an effective matching ratio of 13:1! Ironically, the lower the Challenge Grant actually spent, the higher the effective matching ratio is in this calculation, so higher ratios actually indicate weaker leverage.

21. Schuster and Perkins, *The Regional Corporate Challenge Program.*

22. An excellent summary of these research findings is contained in Charles T. Clotfelter, *Federal Tax Policy and Charitable Giving* (Chicago: University of Chicago Press, 1985).

23. Netzer, *The Subsidized Muse,* pp. 89-93.

24. Gingold, *The Challenge Grant Experience,* pp. 90-91; and George Clack, "A Challenge Grant is a Challenge," *The Cultural Post,* no. 22, 1979.

25. Samuel Lipman, "Funding the Arts: Who Decides?" *The New Criterion*, October 1983, p. 8.

26. Wyszomirski, "The Politics of Art," pp. 224-31.

27. For a presentation of these issues see Alan Feld, Michael O'Hare and J. Mark Davidson Schuster, *Patrons Despite Themselves: Taxpayers and Arts Policy*, A Twentieth Century Fund Report (New York: New York University Press, 1983); J. Mark Davidson Schuster, "Tax Incentives for Charitable Donations: Deeds of Covenant and Charitable Contribution Deductions," *University of San Francisco Law Review* 19, 1985; and J. Mark Davidson Schuster, "Tax Incentives as Arts Policy in Western Europe," in *Nonprofit Enterprise in the Arts: Studies in Mission and Constraint*, Paul J. DiMaggio, ed. (New York: Oxford University Press, 1986).

28. J. Mark Davidson Schuster, "The Non-Fungibility of Arts Funding," in Harry Hillman-Chartrand, ed. *The Arts: Corporations and Foundations* (Ottawa, Canada: The Canada Council, 1985); and Michael Useem and Stephen I. Kutner, "Corporate Contributions to Culture and the Arts," in DiMaggio, ed. *Nonprofit Enterprise in the Arts*.

APPENDIX A: Comparative Table of Matching Grant Programs

Program: French Ministry of Culture and Communication
Le Cofinancement

Type: Co-financing.

Dates: January 1987

Goals: To provide an incentive for arts organizations to search out private support to supplement public support.

Eligible Organizations: Any organization eligible for Ministry funding. Proposals must be those for projects covered under the annual themes for the program. During the first year there were nine such themes separated out from the normal program areas in the Ministry, nineteen themes in the second year. Proposed project has to be approved by the appropriate program area within the Ministry, one of four special commissions set up by artistic discipline, and by a Council for Patronage.

What Is Matchable? ("New" Money) Private contributions, particularly sponsorship. Does not necessarily have to be new or increased support.

Ratio of Match: Ratio varies from project to project. The range has been from

> 1 franc public : 2 francs private

to:

> 5 francs public : 1 franc private.

For each project a minimum level of necessary private support and a maximum level of government match are specified.

Total of Government Match: 28 million francs in 1987.
50 million francs projected for 1988.

Constraints on Use of "New" Private Money: Must be used for the proposed project.

Constraints on Use of Matching Money: Must be used for the proposed project.

Required Documentation: A partnership contract is signed between the arts institution and the Ministry.

Involvement of Intermediary Institution: Two additional levels of approval within Ministry (see above).

Program: National Endowment for the Arts
 Challenge Grant Program

Type: Challenge Grant.

Dates:
Challenge Grant I:	October 1976 - September 1982
Challenge Grant II:	October 1982 - March 1989
Challenge Grant III:	October 1988 -

Note: The information that follows applies to Challenge Grant II.

Goals: Strengthen long-term institutional capacity and enhance artistic quality and diversity by:
– Broadening the base of contributed support,
– Increasing contribution levels,
– Providing a more secure capital base,
– Eliminating debts,
– Developing new long-range artistic ventures,
– Launching a major fundraising campaign.
Eligible Organizations: Arts institutions of national or regional significance. Must have at least a five-year history of artistic programming prior to application.

What Is Matchable? ("New" Money) New and increased contributions over and above a base level of contributions over the four-year period of the grant. Gifts of cash, securities, and tangible property, grants from lower levels of government, and debt forgiveness all qualify.

Ratio of Match: $1.00 Government Match : $3.00 Matchable Contributions.
$1.00 Government Match : $4.00 Matchable Contributions
 for Capital Improvements.
Individual grants no less than $100,000 per organization and no more than $1,000,000.

Total of Government Match: Challenge Grant II
$112 million through FY88
(Challenge Grant I: $111 million over five years).

Constraints on Use of "New" Private Money: Lengthy list of allowable uses that permanently strengthen the balance sheet of the institution.

Constraints on Use of Matching Money: Board must assure that the challenge funds are used for the purpose for which they were granted.

Required Documentation: Initial report, quarterly reports and annual reports prepared according to specified standards.

Involvement of Intermediary Institution: None.

Program: Arts Council of Great Britain
Incentive Funding: Enterprise Fund

Type: Challenge Grant

Dates: September 1988-

Goals: Encourage arts organizations to become more financially enterprising, to improve the management skills and to strengthen their long-term financial bases.

Eligible Organizations: Any arts organization receiving funding from the Arts Council of Great Britain, the Scottish Arts Council, the Welsh Arts Council, or the English Regional Arts Associations, plus arts service organizations. Key senior personnel must have a five-year record of artistic achievement. Priority to organizations of national or regional importance.

What Is Matchable? ("New" Money) Additional earned income or contributions. Expectation that at least 75 percent of the increase will come from earned income sources plus individual contributions rather than from corporate or foundation support or income on endowment.

Ratio of Match: 1 pound Government Match : 2 pounds additional income.

Total of Government Match: 3 million pounds in first year (including Progress Fund). Each grant will be no less than 50,000 pounds and no more than 250,000 pounds.

Constraints on Use of "New" Private Money: Unrestricted.

Constraints on Use of Matching Money: Establishing capital funds; implementing long-term artistic objectives; reducing accumulated deficits; buying equipment; restoring, buying or, in limited cases, constructing premises; or investing in independent trading companies.

Required Documentation: Three-year organizational plan must be prepared and reviewed by an independent business assessor who determines if the organization's plan is "prepared," "feasible" or "premature."

Involvement of Intermediary Institution: Business assessor and other consultants provided by the program.

Program: Arts Council of Great Britain
　　　　　Incentive Funding: Progress Fund

Type:　Challenge Grant

Dates:　September 1988 -

Goals:　Encourage arts organizations to become more financially enterprising, to improve the management skills and to strengthen their long-term financial bases.

Eligible Organizations: Any arts organization receiving funding from the Arts Council of Great Britain, the Scottish Arts Council, the Welsh Arts Council, or the English Regional Arts Associations, plus arts service organizations. Focus on organizations that may be small-scale, newly formed, innovative or community oriented.

What Is Matchable? ("New" Money) Phase one provides an independent consultant to the organization as well as a grant of up to 5,000 pounds. In phase two all kinds of earned income, private sector donations and income from certain public sources, particularly local government, is matchable, but no more than 50 percent can be from this third category.

Ratio of Match: 1 pound Government Match : 2 pounds additional income.

Total of Government Match:　　3 million pounds in first year
　　　　　　　　　　　　　　　　(including Enterprise Fund).
Each grant will be no less than 5,000 pounds and no more than 50,000 pounds.

Constraints on Use of "New" Private Money: Unrestricted.

Constraints on Use of Matching Money: In accordance with organization's business plan.

Required Documentation: Organizational plan prepared during phase one.

Involvement of Intermediary Institution: Consultant provided by the program.

Program: Office of Arts and Libraries, Great Britain
Business Sponsorship Incentive Scheme (BSIS)

Type: Reverse Matching Grant

Dates: October 1984–

Goals: To attract new corporate sponsorship of the arts by offering a measure of government endorsement and financial support.

Eligible Organizations: Originally, any "bona fide arts organization" (including commerical). Now restricted to organizations that have charitable status, that are not profit-distributing or that receive government funds. [Includes organizations that are ineligible for support from the Arts Council of Great Britain.]

What is Matchable? ("New" Money): Increases in corporate sponsorship. Each arts organization can claim a match for one sponsorship per year.

Ratio of Match:
> **Original Rules:**
> 1 pound Government Match: 3 pound increase in Corporation's
> Total Arts Sponsorship
> Increase had to be at least 7,500 pounds with a maximum increase of 75,000 pounds for each sponsorship matched.
> **Current Rules:**
> For first-time sponsorships of 1,000-25,000 pounds by a business that has never sponsored the arts before:
> 1 pound Government Match: 1 pound Sponsorship
> For existing sponsors who increase their total annual arts sponsorship by 3,000-75,000 pounds:
> 1 pound Government Match: 3 pound increase in Corporation's
> Total Arts Sponsorship
> (Each sponsorship matched must have increased by at least 3,000 pounds.)

Total of Government Match: 3.25 million pounds over first 30 months
1.75 million pounds budgeted for current year

Constraints on Use of "New" Private Money: Expenses of the sponsored project

Constraints on Use of Matching Money: Match is "intended to be used in

some part to enhance the sponsorship, . . . ensuring increased benefits for the sponsor."

Required Documentation: Detailed application form filled out by arts organization and sponsor. Arts organizations required to provide audited accounts showing that the match has been used to enhance the vaue of the sponsorship to the sponsor.

Involvement of Intermediary Institution: BSIS is administered for the Office of Arts and Libraries by the Association for Business Sponsorship of the Arts, a nongovernmental, nonprofit organization.

Program: Massachusetts Council on the Arts and Humanities
Regional Corporate Challenge Program

Type: Reverse Matching Grant

Dates: January 1983 - December 1986

Goals: To increase the total dollars given by the business community to the arts, to broaden the base of funders as well as the number of recipients of corporate giving, and to develop a network of interested business-people statewide who would become advocates for the arts in their communities.

Eligible Organizations: Any Massachusetts arts institution that had received some funding from the Council in any year since the fiscal year preceding the creation of the Committee in its region. For a region to be included in the program it had to have at least six eligible institutions and a Regional Business Committee.

What Is Matchable? ("New" Money) Original program design was to match net increases in the aggregate of corporate cash contributions for general operating support in each region with a Regional Business Committee. Eventually, three more costly variations on this rule appeared: matching the net increase in aggregate giving by any member of a Regional Business Committee, matching the net increase in corporate contributions made to a particular institution, or matching the net increase in giving by a particular corporation to a particular organization.

Ratio of Match: $1 Government Match : $1 Matchable Corporate Donations. Originally the match was to have been subject to an upper limit set by the approved annual fundraising goal for each Regional Business Committee (and used to budget for the program).

Total of Government Match: $2.36 million over four years of program.

Constraints on Use of "New" Private Money: Ongoing operating expenses.

Constraints on Use of Matching Money: No restrictions, though it was hoped that organizations would not put expected matches into their ongoing budgets.

Required Documentation: Annual request for match prepared by each Regional Business Committee and reviewed by Council staff.

Involvement of Intermediary Institution: Regional Business Committee required for a region to participate in the program. Committees were eventually created in eight regions, three of which were set up as United Arts Funds. Boston excluded from program.

Program: Ontario Ministry of Culture and Recreation
Wintario Arts Challenge Fund

Type: Reverse Matching Grant

Dates: June 1980 - March 1983

Goals: Encourage major nonprofit arts organizations to achieve greater long-term financial stability by:
- Assisting in establishment of an investment (endowment) fund to provide long-term operating income,
- Increasing current level and broadening base of private/corporate support,
- Acting as an incentive toward elimination of accumulated deficits and
- Benefiting arts organizations without creating a dependency on lottery or tax funds.

Eligible Organizations: Ontario arts organizations with operating budgets $250,000, which already were receiving annual assistance from the Ontario Ministry of Culture and Recreation or the Ontario Arts Council. [35 organizations]

What Is Matchable? ("New" Money) Individual, business and foundation donations above the "base fundraising level," determined by calculating the average percentage of operating income raised through private fundraising in the previous three to five years and multiplying that percentage by current year's operating expenses.

Ratio of Match: $2.00 Government Match : $1.00 Matchable Private Donations. Subject to a grant ceiling for each organization.

Total of Government Match: $18 million over three-year program.

Constraints on Use of "New" Private Money: Donations over the base must be used for:
- Retirement of debt accumulated in a previous year, then
- Inclusion into a separate investment (endowment) fund, or
- An approved special project extraordinary to normal operating expenses for which a future funding expectation will not be created.

Constraints on Use of Matching Money: Must be placed into an investment (endowment) fund. Interest income must be available for ongoing operations. Principal must remain in fund for five years.

Required Documentation: Detailed application with audited financial statements and details of proposed fundraising campaign. Strict require-

ments for documentation of matching grant in organization's future financial statements.

Involvement of Intermediary Institution: None.

Program: Ontario Ministry of Citizenship and Culture
Investment in the Arts

Type: Reverse Matching Grant

Dates: June 1986 -

Goals: To help Ontario-based nonprofit arts organizations receiving provincial support achieve long-term financial stability by:
- Eliminating/reducing accumulated deficits and balancing current operating budgets,
- Encouraging greater donations from the public and corporate community,
- Encouraging the development of more sophisticated fundraising techniques and financial management capabilities through the provision of matching incentives and endowment fund management requirements,
- Providing support for northern arts organizations and
- Supporting arts organizations in obtaining new corporate donors.

Eligible Organizations: Ontario arts organizations with operating budgets > $75,000 which have been in existence at least three years and are currently receiving annual assistance from the Ontario Arts Council, and Arts Service Organizations supported by the Ministry of Citizenship and Culture. (> $50,000 budget for art schools providing professional training, cultural centres, and arts organizations in northern communities.) [220 organizations]

What Is Matchable? ("New" Money) Same calculation (based on three previous years). Only cash donations are matchable. Restrictions on matchability of donations from foundations or other bodies related to applicant institution. Funds raised for a capital project or to satisfy any previous Wintario matching requirement are ineligible for match.

Ratio of Match: $1.00 Government Match : $1.00 Matchable Private Donations. Plus:
$1.00 Government Match for each dollar contributed by corporations that have not made a cash contribution to the arts in the previous four years. Subject to a grant ceiling for each organization.

Total of Government Match: No figures yet available.

Constraints on Use of "New" Private Money: Private donations over the base must be placed in an endowment fund for at least a five-year period. Interest on the endowment is available for operating expenses.

Constraints on Use of Matching Money: Must be used to retire an existing or

accumulated deficit incurred during the three-year participation period or be placed in an endowment fund.

Required Documentation: Detailed application with audited financial statements and details of proposed fundraising campaign. Letter from corporation attesting that it is a new donor. Strict requirements for documentation of matching grant in organization's financial statements.

Involvement of Intermediary Institution: None.

ABOUT THE AMERICAN COUNCIL FOR THE ARTS

The American Council for the Arts (ACA) is one of the nation's primary sources of legislative news affecting all of the arts and serves as a leading advisor to arts administrators, educators, elected officials, arts patrons and the general public. To accomplish its goal of strong advocacy of the arts, ACA promotes public debate in various national, state and local forums; communicates as a publisher of books, journals, *Vantage Point* magazine and *ACA UpDate*; provides information services through its extensive arts education, policy and management library; and has as its key policy issues arts education, the needs of individual artists, private-sector initiatives, and international cultural relations.

Esther Wachtell
Vivian M. Warfield
Mrs. Gerald H. Westby
Mrs. Pete Wilson

MAJOR CONTRIBUTORS

GOLDEN BENEFACTORS
($75,000 and up)
American Telephone &
Telegraph Company
Gannett Foundation
Southwestern Bell

BENEFACTORS
($50,000-$74,999)
Aetna Life & Casualty Company
The Ahmanson Foundation
National Endowment for the Arts

PACESETTERS ($25,000-$49,999)
American Re-Insurance Co.
Mr. and Mrs. Jack S. Blanton, Sr.
The Coca-Cola Company
Eleanor Naylor Dana Trust
Interlochen Arts Center
Johnson & Johnson
Philip Morris Companies, Inc.
New Jersey State Council on
 the Arts
The Reed Foundation
The Ruth Lilly Foundation
Sears, Roebuck & Co.
Elton B. Stephens
Mr. and Mrs. Richard L. Swig

SUSTAINERS ($15,000-$24,999)
Bozell, Jacobs, Kenyon
 & Eckhardt
Geraldine R. Dodge Foundation
Exxon Corporation
IBM Corporation
Mutual Benefit Life
Peat Marwick & Main
Reverend and Mrs. Alfred R.
 Shands III
John Ben Snow Memorial Trust
Metropolitan Life Foundation
Rockefeller Foundation
The San Francisco Foundation
John Straus

SPONSORS ($10,000-$14,999)
ARCO
Ashland Oil, Inc.
Equitable Life Assurance Society
Toni K. Goodale
The Irvine Company
Susan R. Kelly
N.W. Ayer, Inc.
Mrs. Charles Peebler
Murray Charles Pfister
New York Community Trust
The Prudential Foundation
Mr. and Mrs. Paul Schorr III
Starr Foundation

DONORS ($5,000-$9,999)
The Allstate Foundation
American Stock Exchange, Inc.
Ameritech
The Arts, Education and
Americans, Inc.
BATUS, Inc.
Bell Atlantic
Mary Duke Biddle Foundation
Boeing Company
Mr. and Mrs. Martin Brown
Chase Manhatten Bank
CIGNA Corporation
Dayton Hudson Foundation
Joseph Drown Foundation
Jeaneane B. Duncan
Sunny Dupree, Esq.
Federated Investors, Inc.
The First Boston Corporation
Ford Motor Company Fund
Gannett Outdoor
Goldman, Sachs & Company
Mr. and Mrs. John Hall
David H. Harris
Louis Harris
The Hartford Courant
Howard S. Kelberg
Ellen Liman
The Joe and Emily Lowe
 Foundation, Inc.
Lewis Manilow
MBIA, Inc.
Merrill Lynch, Pierce, Fenner
 &Smith Inc.
Mobil Foundation, Inc.

Morgan Guaranty Trust Company
J.P. Morgan Securities
Morgan Stanley & Co.
Morrison-Knudsen Corporation
New York Times Company
 Foundation
Pacific Telesis Group
RJR Nabisco
General Dillman A. Rash
David Rockefeller, Jr.
Henry C. Rogers
Mr. and Mrs. LeRoy Rubin
Shell Companies Foundation
Schering Corporation
Allen M. Turner
Warner-Lambert Company
Whirlpool Foundation
Xerox Foundation

CONTRIBUTORS ($2,000-$4,999)

Abbott Laboratories
Alcoa Foundation
Allied Corporation
American Electric Power
 Company, Inc.
American Express Foundation
Mr. and Mrs. Curtis L. Blake
Gerald D. Blatherwick
Edward M. Block
Borg-Warner Co.
Mrs. Eveline Boulafendis
Donald L. Bren
Bristol-Myers Fund
C.W. Shaver
Terri and Timothy Childs
The Chevron Fund
Robert Cochran
Mr. and Mrs. Hill Colbert
Mr. and Mrs. Donald G. Conrad
Barbaralee Diamonstein-
 Spielvogel
Mr. and Mrs. Charles W.
 Duncan, Jr.
Mrs. George Dunklin
Eastman Kodak Company
Emerson Electric
Ethyl Corporation
GFI/KNOLL International
 Foundation
Donald R. Greene
Eldridge C. Hanes

Mr. and Mrs. Irving B. Harris
Ruth and Skitch Henderson
Henry C. Kates
John Kilpatrick
Knight Foundation
Kraft, Inc.
Mr. Robert Krissel
Frank W. Lynch
Marsh & McLennan Companies
Mr. and Mrs. John B. McCory
Monsanto Company
Robert M. Montgomery, Jr.
Velma V. Morrison
New York Life Foundation
The Overbrook Foundation
Mr. and Mrs. Thomas Pariseleti
Procter & Gamble Fund
Raytheon Company
Mr. and Mrs. Richard S.
 Reynolds III
Judith and Ronald S. Rosen
Sara Lee Corporation
Frank A. Saunders
David E. Skinner
Union Pacific Foundation
Mrs. Gerald H. Westby
Westinghouse Electric Fund
Mrs. Thomas Williams, Jr.

FRIENDS ($1,000-$1,999)

Morris J. Alhadeff
Mr. and Mrs. Arthur G. Altschul
Mrs. Anthony Ames
AmSouth Bank N.A.
Archer Daniels Midland Co.
Mr. Wallace Barnes
Anne Bartley
Bell South
Mr. and Mrs. Evan Beros
Binney & Smith
T. Winfield Blackwell
Houston Blount
Bowne of Atlanta, Inc.
William A. Brady, M.D.
Alan Cameros
Gary T. Capen
Mr. and Mrs. George Carey
Chris Carson
Mrs. George P. Caulkins
Mr. Campbell Cawood
Mrs. Jay Cherniack

Chesebrough-Pond's Inc.
Chrysler Corporation
Citizens and Southern
 Corporation
David L. Coffin
Mr. and Mrs. Marshall Cogan
Thomas B. Coleman
Cooper Industries Foundation
Mrs. Howard Cowan
Cowles Charitable Trust
John G. Crosby
Cummins Engine Foundation
Mrs. Crittenden Currie
David L. Davies
Carol Deasy
Jennifer Flinton Diener
Eugene C. Dorsey
Ronald and Hope Eastman
EBSCO Industries, Inc.
Mrs. Hubert Everist
Mary and Kent Frates
Stephanie French
Frederick P. Furth
Mr. and Mrs. Edward Gaylord
Dr. and Mrs. John M. Gibbons
Mr. and Mrs. Edward Gildea
Lee Gillespie
Mr. and Mrs. Robert C.
 Graham, Jr.
Lois Lehrman Grass
Richard M. Greenberg
Mr. and Mrs. W. Grant Gregory
Bernice Grossman and
 Stephen Belth
R. Philip Hanes, Jr.
Mr. and Mrs. Joseph Helman
Mrs. Skitch Henderson
Edward I. Herbst
Admiral and Mrs. B.R. Inman
Mrs. Lyndon B. Johnson
Mr. and Mrs. Thomas Jolly
Alexander Julian
L. Paul Kassouf
Mrs. Albert S. Kerry
Shane Kilpatrick
Mrs. Roy A. Kite
Mrs. James Knapp
Henry Kohn
Mrs. C.L. Landen, Jr.
Mrs. Wilbur Layman

Fred Lazarus IV
Thomas B. Lemann
Robert Leys
Dr. and Mrs. James L. Lodge
Mrs. Robert Lorton
Mr. and Mrs. I.W. Marks
Mr. and Mrs. Peter Marzio
Mr. and Mrs. James W. McElvany
Florri D. McMillan
Tim McReynolds
Mrs. Michael A. Miles
Mr. and Mrs. Reese L. Milner II
Wendy and Alan Mintz
Mr. and Mrs. George Mitchell
Mr. and Mrs. Robert Mosbacher
Sondra G. Myers
Mr. and Mrs. William G. Pannill
Pantone, Inc.
Diane Parker
Mr. and Mrs. R. Scott Pastrick
Jane Bradley Petit
Mr. and Mrs. Harry Phillips, Jr.
Phillips Petroleum Foundation
Mrs. Arliss Pollock
Mr. and Mrs. John Powers
W. Ann Reynolds
William T. Reynolds
Mrs. Kay Riordan-Steuerwald
Mr. and Mrs. William A. Roever
Ronald S. Rosen
Mr. and Mrs. Eugene S. Rosenfeld
Rubbermaid, Inc.
Mrs. William A. Schreyer
Security Pacific Foundation
Dr. James H. Semans
Marie Walsh Sharpe Art
 Foundation
Gary F. Sherlock
Dorman and Shirley Shockley
Kathleen Daubert Smith
Richard K. Smucker
Sotheby's North America
Thomas K. Standish
Mr. and Mrs. Stephen D. Susman
Tandy Corporation
Mr. and Mrs. Thomas R. Tellefsen
Textron Charitable Trust
Gerald Thornton
Mr. and Mrs. Thomas Troubridge
Robert Peter Tufo